RACKHAM'S COLOR ILLUSTRATIONS FOR WAGNER'S "RING"

ARTHUR RACKHAM

WITH AN INTRODUCTION AND
CAPTIONS BY JAMES SPERO

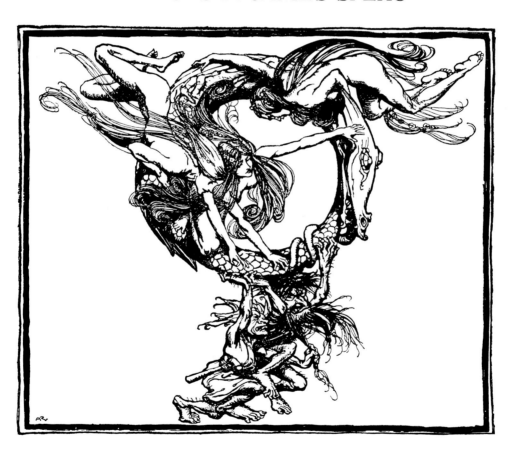

DOVER PUBLICATIONS INC. · NEW YORK

Rackham's Color Illustrations for Wagner's Ring is a new
work, first published in 1979. The color illustrations, here repro-
duced in their entirety, and the black-and-white vignettes and
tailpieces, here reproduced in a selection, appeared in two
volumes, both published by William Heinemann, London, and
Doubleday, Page & Co., New York: *Siegfried & the Twilight
of the Gods* (1911) and *The Rhinegold & The Valkyrie* (1912).
The introduction and captions have been written by James Spero.

International Standard Book Number: 0-486-23779-6
Library of Congress Catalog Card Number: 78-73985

Manufactured in the United States of America
Dover Publications, Inc.
180 Varick Street
New York, N.Y. 10014

INTRODUCTION

According to a romantic tradition, the family into which Arthur Rackham was born in London on September 19, 1867 was descended from John Rackham, who had been hanged as a pirate in 1720. Be this as it may, Arthur's immediate family was conventionally and respectably middle class, his father having worked his way up in the civil service to the post of Admiralty Marshall.

Young Arthur's passion for art was such that, made to retire early, he would smuggle a pencil and paper into bed with him to continue his sketching. During his childhood he was greatly impressed by Arthur Boyd Houghton's illustrations for *The Arabian Nights* in the Dalziel edition of 1865. It is also safe to assume that he was exposed to the fantastic creations of Richard Doyle. In 1879 he was admitted to the City of London School, Cheapside, where he won a prize for drawing.

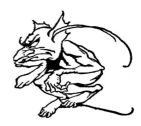

In 1884 Rackham was sent to Australia in the hope that the bracing sea air would improve his delicate health. Returning to London that autumn, he enrolled in the Lambeth School of Art, where fellow students included Charles Ricketts, Thomas Sturge Moore and Leonard Raven-Hill. For all his creative imagination, Rackham was levelheaded. Entering the world of business as a statistician in an insurance company, he continued his practice of art at night, submitting work to the many illustrated weeklies that were published at the time. His first published drawing appeared in 1884 in *Scraps*. By 1893, Rackham had established enough of a reputation that he was invited to join the staff of the newly formed *Westminster Budget*.

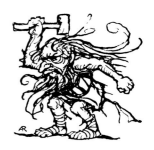

Now working as a full-fledged graphic journalist, Rackham was called upon to illustrate themes ranging from royal events and robberies to theatrical presentations. While he was starting out on this career, the method of printing illustrations was undergoing a revolution. Previously, an artist's drawing had to be copied onto a block of wood by an engraver, who would frequently alter the original to meet the limitations of either the medium or his ability. Now, by means of the photo-zinc process, line drawings could be reproduced directly, eliminating this artistic middleman. Also, the halftone method of reproducing artwork with grada-

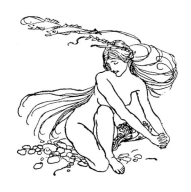

tions of tone had been developed. These innovations greatly widened the technical resources of graphic journalists, but at the same time they spelled their doom, for photographs could now be reproduced in publications, rendering these artists superfluous.

But Rackham was already veering away from graphic journalism toward illustration of stories and books. His first book had appeared in 1893: *To the Other Side,* published as a travel brochure for the Norddeutsch Lloyd Company. The next year he executed four illustrations for Anthony Hope's *The Dolly Dialogues.* With work published in periodicals such as *Little Folks* (to which he began contributing in 1896), Rackham was moving toward his true calling. The world of illustration was bustling in the 1890s, and Rackham must have been influenced by the work of contemporary artists such as Howard Pyle, J. F. Sullivan, Charles Robinson, Archie MacGregor and Alice B. Woodward. Aubrey Beardsley, too, was at the height of his meteoric career, and Rackham fell under his spell although he did radically adapt Beardsley's style to meet his own purposes.

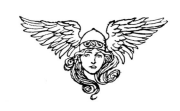

It was in 1900, with Rackham's edition of *Grimm's Fairy Tales* (95 black-and-white illustrations with a colored frontispiece), that the artist first achieved recognition. (These illustrations were later redone, many as watercolors, for the edition of 1909.) In 1905 his reputation was firmly established with the publication of *Rip van Winkle*. His 51 watercolor illustrations to Washington Irving's classic possess all the well-known Rackham hallmarks: the unique interpretation of otherworldly beings, the appealing portrayal of children, a deep feeling for landscape and plantlife (especially for gnarled trees), and an ironclad technique highlighted by a deft line and the delicate application of washes of subdued color. The book was published by William Heinemann, establishing a relationship which, although not exclusive, lasted for many years. A pattern of publication soon emerged. First a limited edition was issued, followed by a trade edition, the American edition (published by Doubleday, Page & Co.) and a French edition. All are now eagerly sought by collectors.

This success was quickly followed by another. *Peter Pan in Kensington Gardens* (1906) was rapturously received by the public as well as by the author, James Barrie. Rackham's illustrations for *Alice's Adventures in Wonderland* (1907) ran up against the prejudice the public has always held against any artist attempting an interpretation differing from that of John Tenniel, illustrator of the original. In 1908 Rackham's illustrations to Shakespeare's *A Midsummer-Night's Dream* appeared. They are thought by many to be his masterpiece, although his treatment of *Undine* (1909) is in no way inferior. By 1910 Rackham had become the leading illustrator of the period, not only making an excellent living from the royalties from his books, but also getting good prices for the sale of the original watercolors after exhibition in London galleries. In 1920, his peak year, his income soared to £7000.

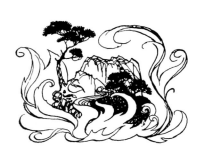

In 1909, Rackham set about illustrating Richard Wagner's operatic tetralogy *Der Ring des Nibelungen* (The Nibelung's Ring), which consists of a prologue *(Das Rheingold)* followed by three "days"—*Die Walküre* (The Valkyrie), *Siegfried* and *Die Götterdämmerung* (The Twilight of the Gods). In these illustrations

Rackham saw the opportunity to create something on a grander, more prestigious plane than in his former work; since the first performances of the "Ring" in August 1876, the world had attached unusual importance to the cycle. For the premiere performances luminaries had flocked to the sleepy Bavarian town of Bayreuth, where Wagner had built his Festspielhaus expressly for presentation of the cycle. The works rocked musical Europe, as had every Wagnerian opera since *Der fliegende Holländer*. Wagner died in 1883, but by the turn of the century the prestige of his operas had grown to the point where they held a status that was almost religious. After the Second World War they were placed in a more realistic perspective, but it is important to remember the significance they held in Rackham's time.

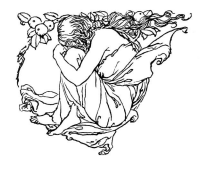

Rackham's illustrations for the "Ring" appeared in two volumes, both published by Heinemann. The first, *The Rhinegold & The Valkyrie,* was issued in 1910; the second, *Siegfried & The Twilight of the Gods,* in 1911. Both were accompanied by an English translation by Margaret Armour of a type then frequently encountered and now best forgotten.

On these 64 watercolor illustrations Rackham lavished all of his skill and craft, paying the strictest attention to the text throughout. (There is one odd lapse. On page 59 the plotting Brünnhilde and Hagen are shown in an interior, rather than out of doors, as the action occurs in the opera.) His character observation is keen. The portrait, page 58, of Grimhilde (who is only alluded to in the "Ring" and never actually seen on stage) is a penetrating study of a woman who can overcome the physical repugnance she feels toward Alberich through the prospect of material gain. Agitation and desperation are perfectly conveyed in the stormy meeting of Waltraute and Brünnhilde (page 56). Rackham also succeeds at the grand, heroic moments. The stylization of Wotan's invocation of Loge (page 32) displays boldness of invention; Brünnhilde's Immolation (page 63) is a perfect rendition of what must be the most difficult scene in all opera to present visually. Nor are any of these characters, not even the Nibelungs, designed to entertain youngsters; Rackham held that the work was strictly for adults. As he wrote to a young admirer, the illustrations "are not well suited for those lucky people who haven't yet finished the delightful adventure of growing up." Nevertheless, C. S. Lewis, who was thirteen when the second volume was published, later wrote of it in *Surprised by Joy,* "His pictures, which seemed to me then to be the very music made visible, plunged me a few fathoms deeper into my delight. I have seldom coveted anything as I coveted that book . . ."

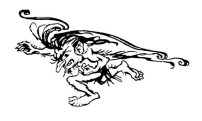

Adults were indeed quick to grasp the quality of these particular illustrations. In 1912 the original watercolors were exhibited in Paris at the Societé Nationale des Beaux Arts (in which the artist was made an Associate, having been given a Gold Medal). At present the originals are presumably in private hands, but the illustrations have remained fixed in the public's mind as a legacy of the traditional approach to Wagner, and are now consulted by those concerned with a more literal presentation of the operas, stripped of the excesses many modern European directors and designers have imposed on the cycle.

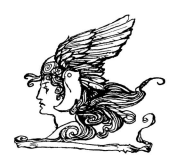

After the carnage of the First World War, the general climate was not as

suitable for Rackham's whimsical world of elves, sprites and fairies as it had been. Several of his new works tackled new themes: *The Vicar of Wakefield* (1929); *The Compleat Angler* (1931); *Poe's Tales of Mystery* (1935). His sole venture into the theater was for Basil Dean's production of *Hansel and Gretel,* which opened at the Cambridge Theatre, London, on Boxing Day, 1933. While the public was enthusiastic about his sets and costumes, the artist himself was less than satisfied.

One of the few sorrows of Rackham's life had been his inability to accept, because of previous commitments, Kenneth Grahame's invitation to illustrate the first edition of *The Wind in the Willows.* It is thus entirely appropriate that as his final work he executed 16 watercolors and several vignettes in black and white to illustrate the adventures of Rat, Mole and Toad. Having illustrated over 90 books, Rackham died on September 6, 1939 at Limpsfield. The next year a new edition of *The Wind in the Willows,* designed by the famed Bruce Rogers, was published by the Limited Editions Club, New York. It was universally felt that, to the last, the master's touch had not faltered.

This edition presents all 64 color illustrations to the "Ring" (slightly enlarged from their published sizes) as well as some of the black-and-white vignettes and tailpieces from the two volumes. The color plates have been captioned so that the reader unfamiliar with the intricacies of the "Ring" will be able to follow the story and see how each illustration pertains to it. It is not a complete plot synopsis; the "Ring" is too large to be fully treated in 64 illustrations, and Rackham's selection of themes reflects his own personal taste. To keep the narration clear, it was therefore necessary to make an occasional slight alteration in the sequence of plates from that of the original.

JAMES SPERO

THE PLATES

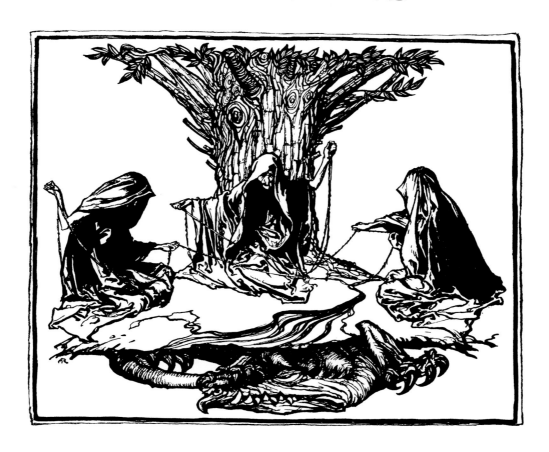

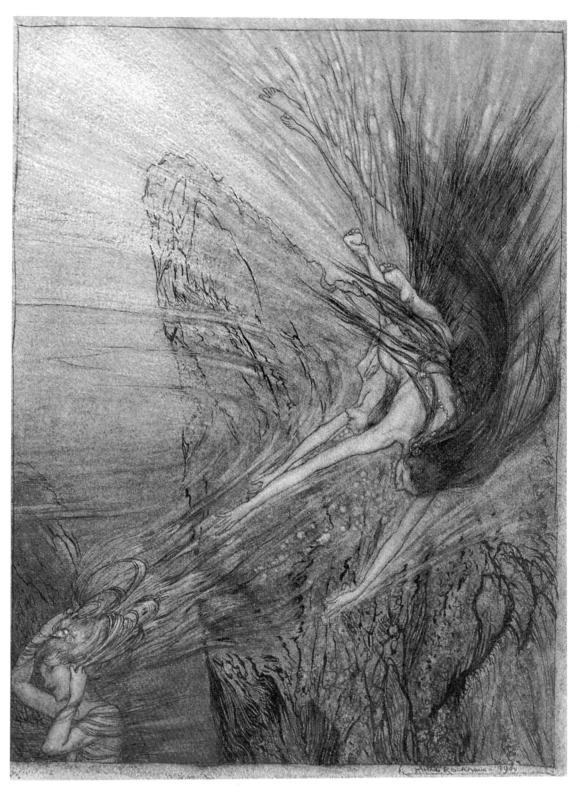

The three Rhinemaidens—Woglinde, Wellgunde and Flosshilde—frolic in the depths of the mighty River Rhine. It is their task to guard the Rhinegold. In the waters the gold is pristine ore; taken and fashioned into a ring, it would confer on the wearer measureless power. But to be able to seize the gold, a person must first renounce love. The Rhinemaidens are sure no one would be willing to make such a sacrifice.

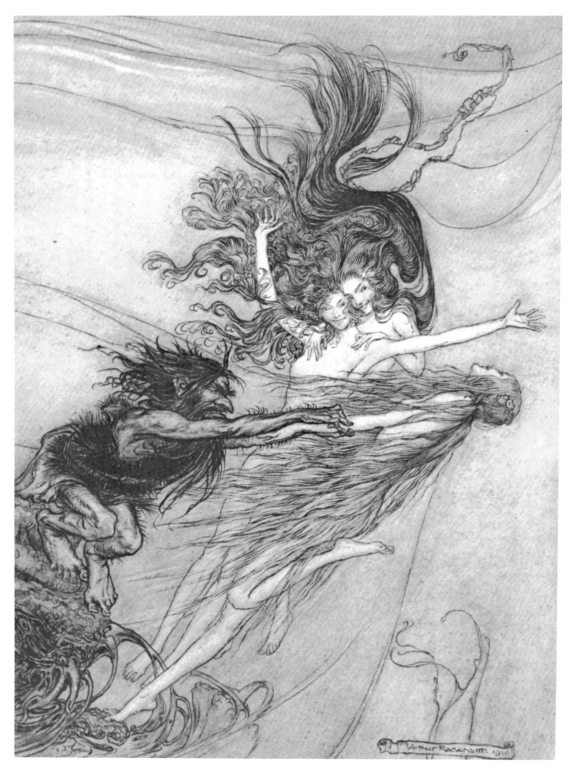

From a fissure in a rock appears Alberich, one of the Nibelungs, a race of dwarfs who dwell beneath the earth. He falls desperately in love with the alluring Rhinemaidens, who tease him heartlessly.

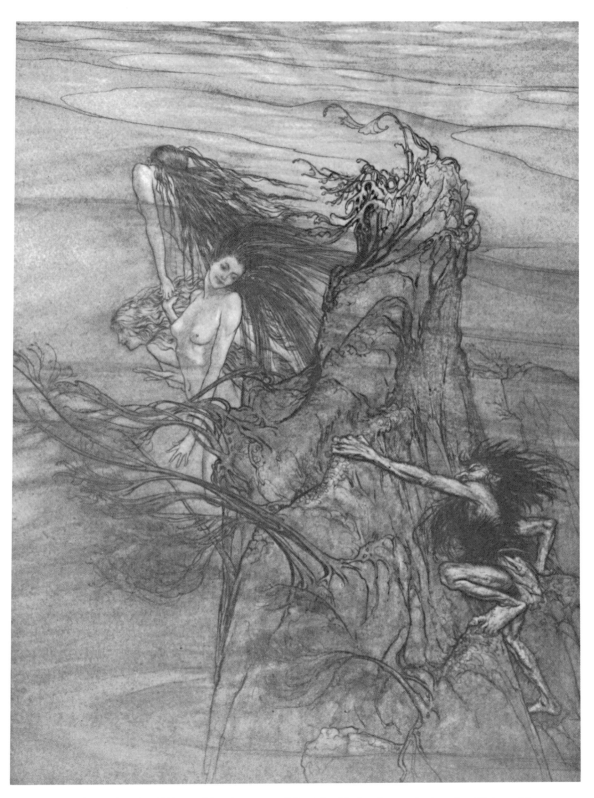

Infuriated by the Rhinemaidens' taunts, Alberich climbs the rock for the Rhinegold.

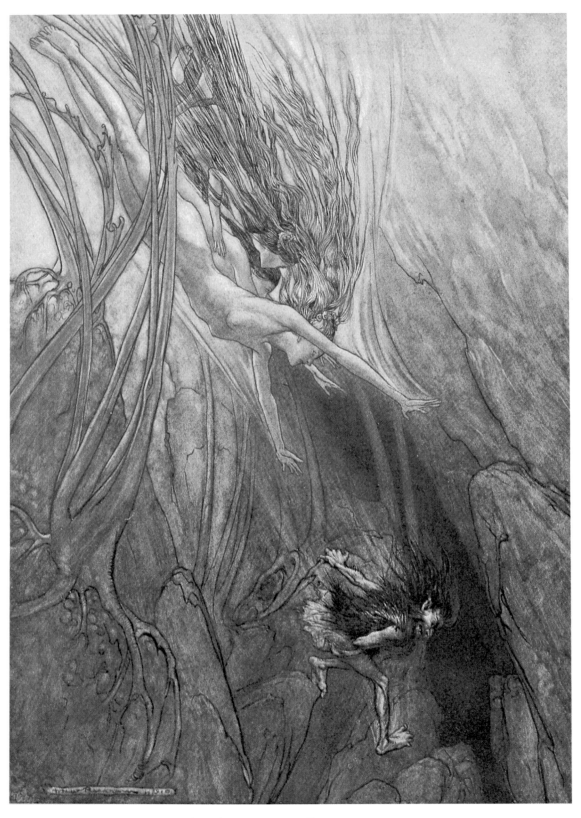

Alberich steals the Rhinegold and rushes off, plunging the waters into darkness.

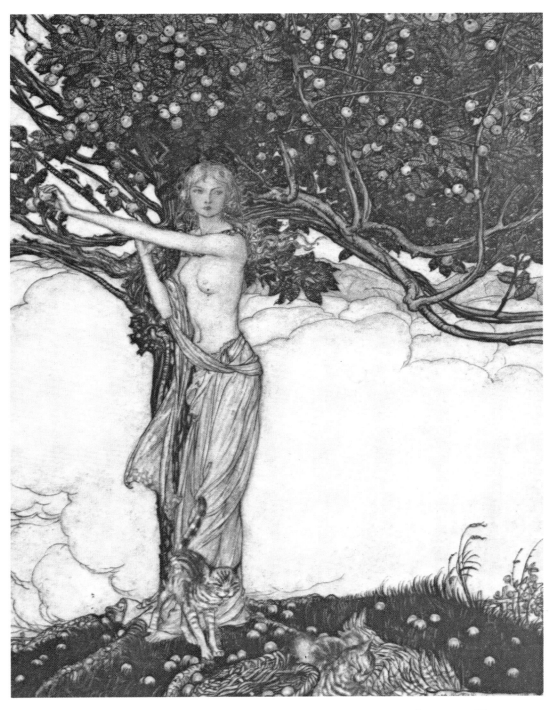

Freia, the goddess of youth, grows apples which keep the gods eternally young. Wotan, the chief god, has offered her to the giants Fasolt and Fafner as payment for building the fortress Walhalla, never thinking that they could accomplish the task. This they have done, and Wotan desperately tries to offer other payment. He is refused.

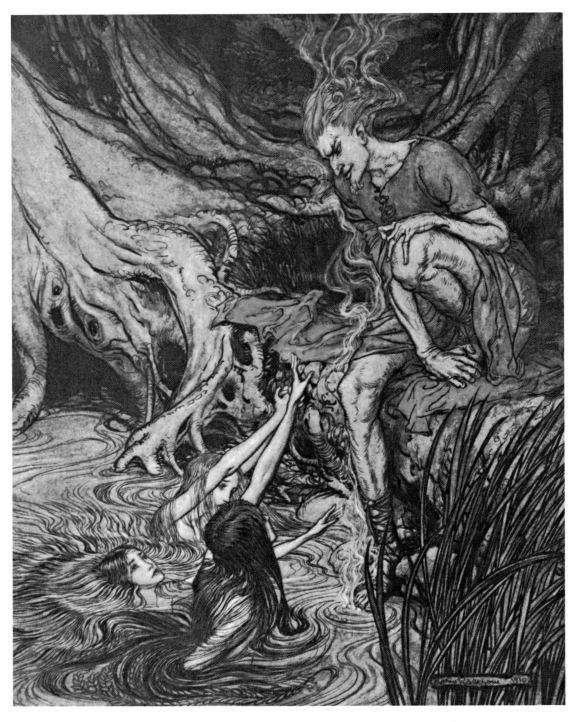

Loge, the god of fire and mischief, tells the other gods that he has seen the Rhinemaidens, who told him of the gold's theft and implored him to have Wotan recover it and return it to their safekeeping.

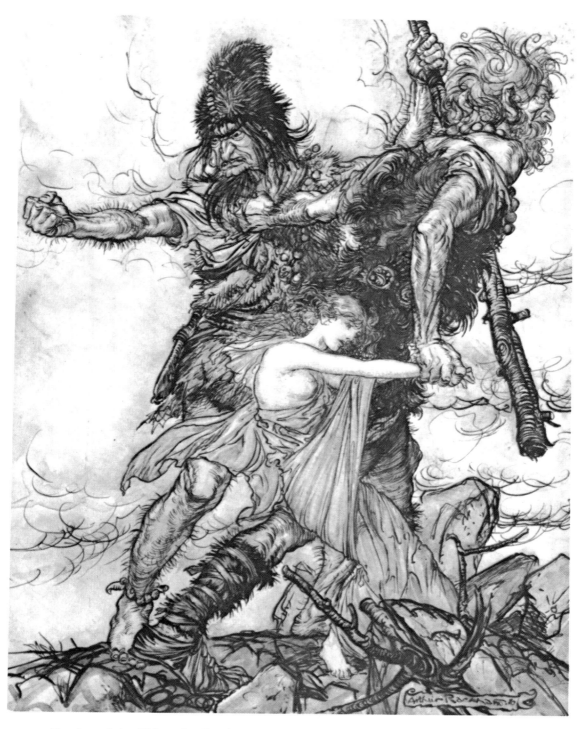

Hearing of the Rhinegold, Fasolt and Fafner decide that it would make an acceptable substitute for Freia. Charging Wotan to steal the gold and have it on hand by evening, they carry off Freia.

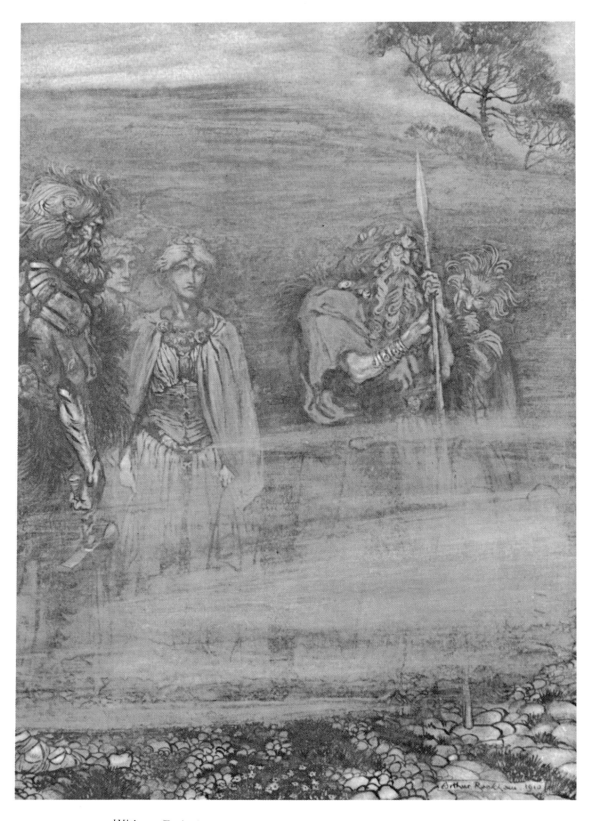

Without Freia in their midst, the gods immediately begin to age.

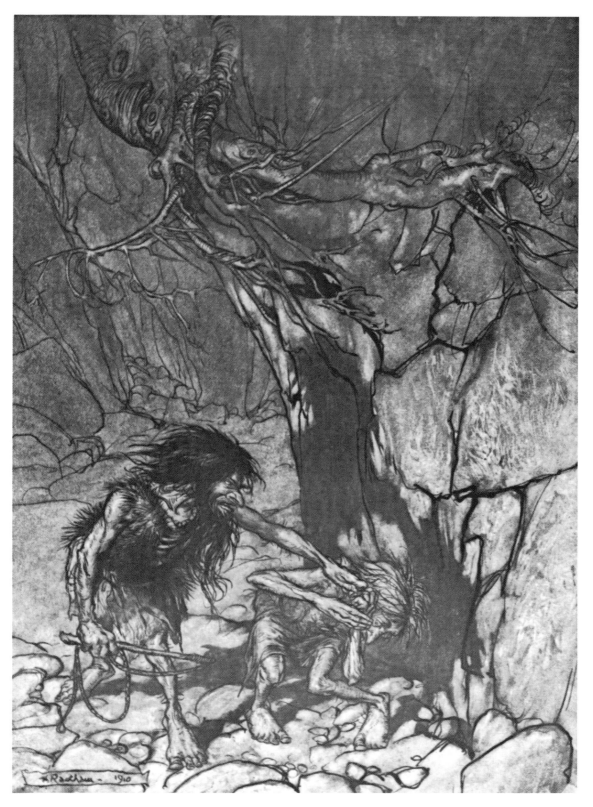

In a cavern, Alberich, having forged the ring, has compelled his brother Mime to fashion the magical Tarnhelm, a cap that allows its wearer to change his form or become invisible.

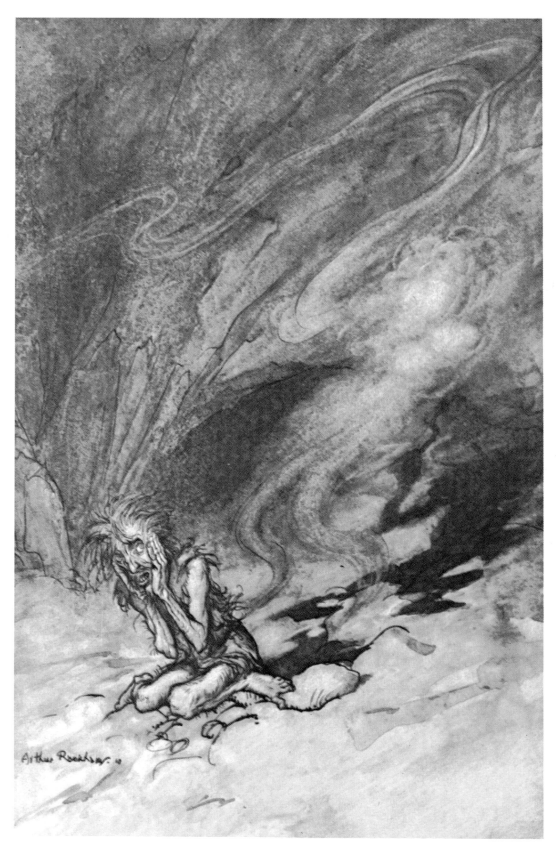

Putting on the Tarnhelm, Alberich is rendered invisible, terrifying Mime.

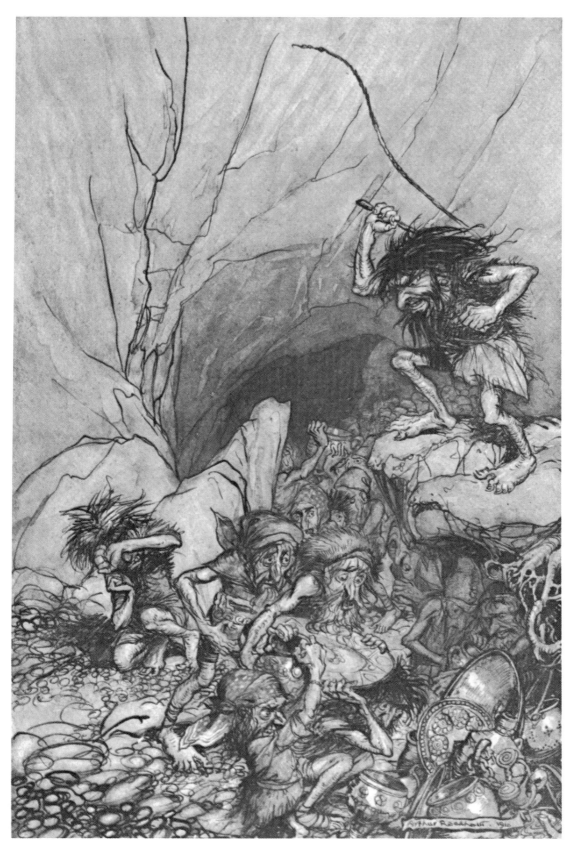

Alberich has wielded his incredible power, enslaving the Nibelungs and forcing them to mine gold and fashion it into a great treasure.

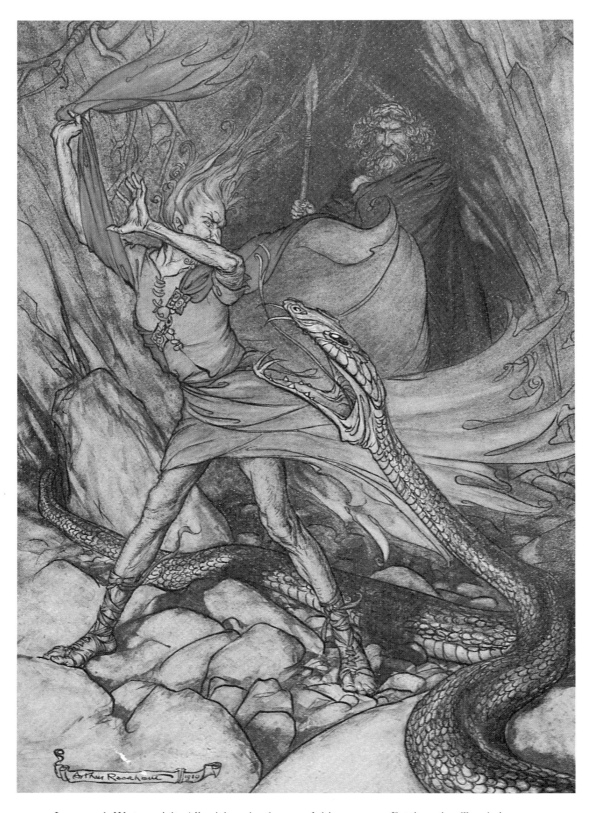

Loge and Wotan visit Alberich, who brags of his powers. Putting the Tarnhelm on his head, he turns himself into a huge serpent. When Loge asks Alberich if he can also turn himself into something small, the dwarf becomes a toad. Loge and Wotan quickly seize him and carry him away.

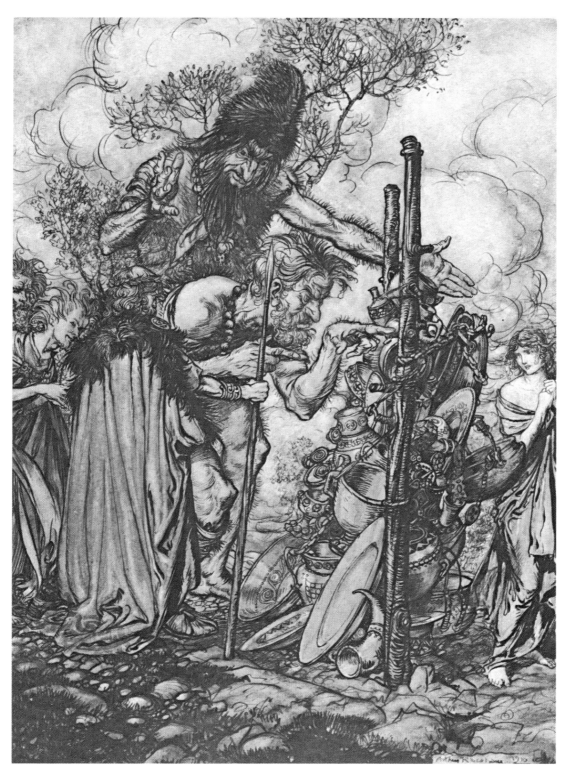

Alberich is held for ransom. He summons the Nibelungs, who surrender the golden
hoard. Wotan forces Alberich to give up the ring as well. Shattered, Alberich curses
the ring—may its wearer be doomed! The giants Fasolt and Fafner return with Freia,
and order that the treasure be stacked up high enough to block her from their sight.

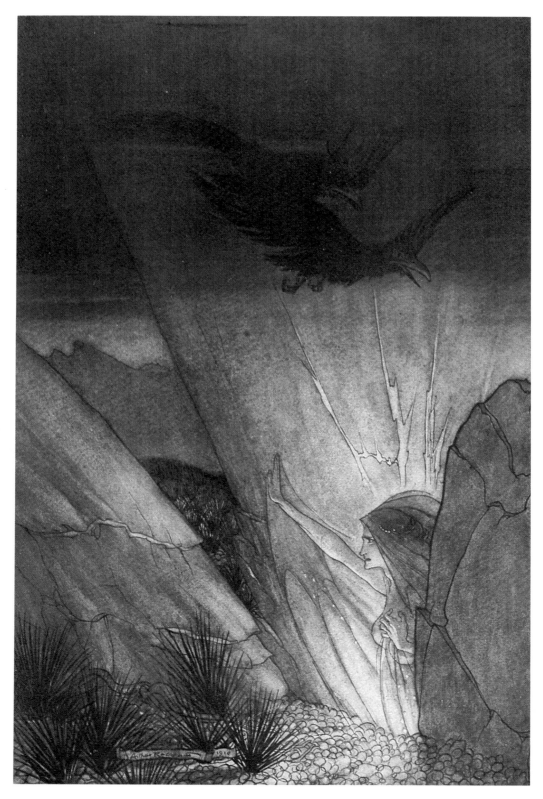

But a chink remains in the pile through which they can see Freia. They tell Wotan to
fill it with the ring which he is wearing. He refuses, wanting to keep it and its power
for himself. Erda, the all-knowing earth goddess, suddenly appears and admonishes
Wotan to give up the ring. Warning him that the race of the gods is doomed, she
disappears.

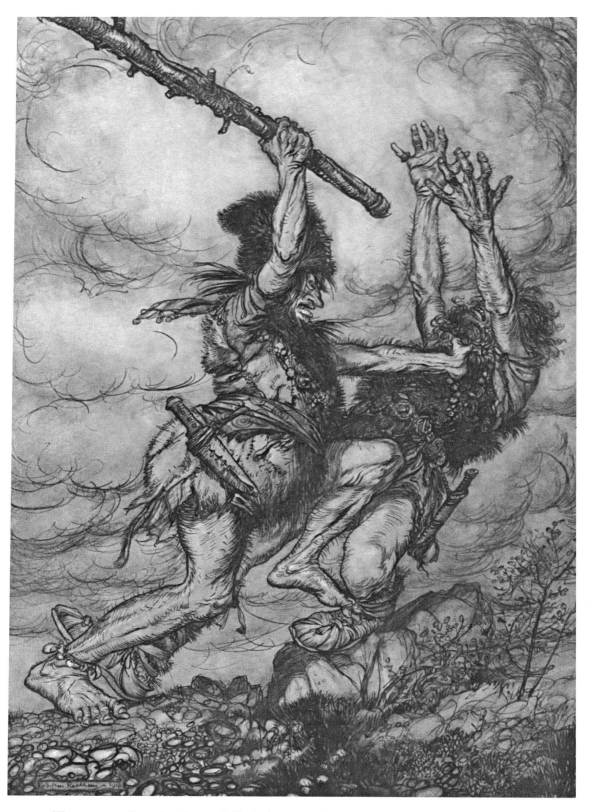

Wotan surrenders the ring and Freia is returned. As the two giants argue over the division of the treasure, Fasolt puts on the ring. He is immediately slain by Fafner, who takes the ring and the entire hoard and leaves.

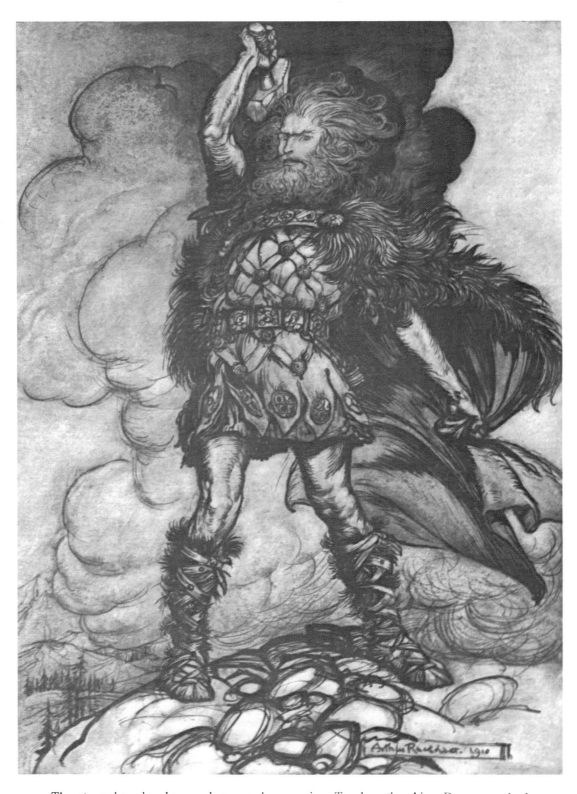

The atmosphere has become heavy and oppressive. To clear the skies, Donner, god of weather, creates a thunderstorm by swinging his hammer.

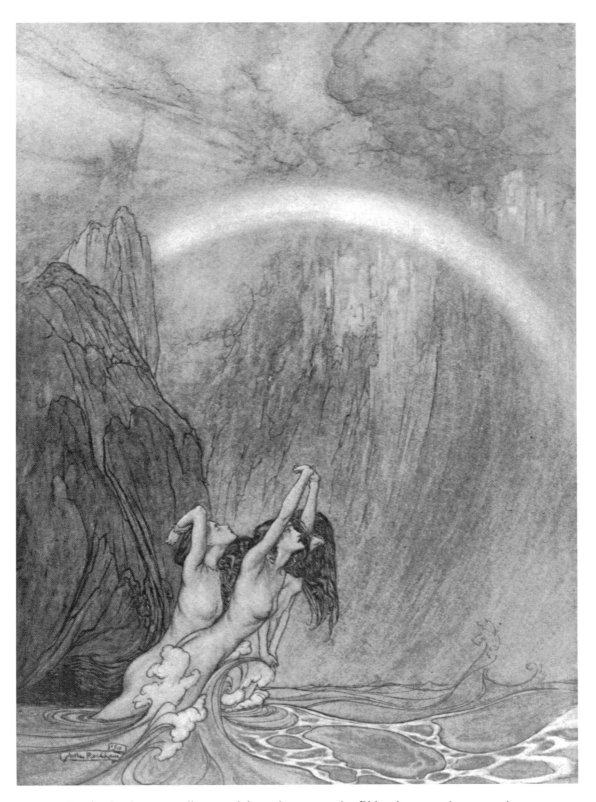

The clouds clear, revealing a rainbow that spans the Rhine between the mountain on which the gods are standing and Walhalla. Ignoring the Rhinemaidens' lamentation for their lost gold, the gods cross the rainbow and enter the castle.

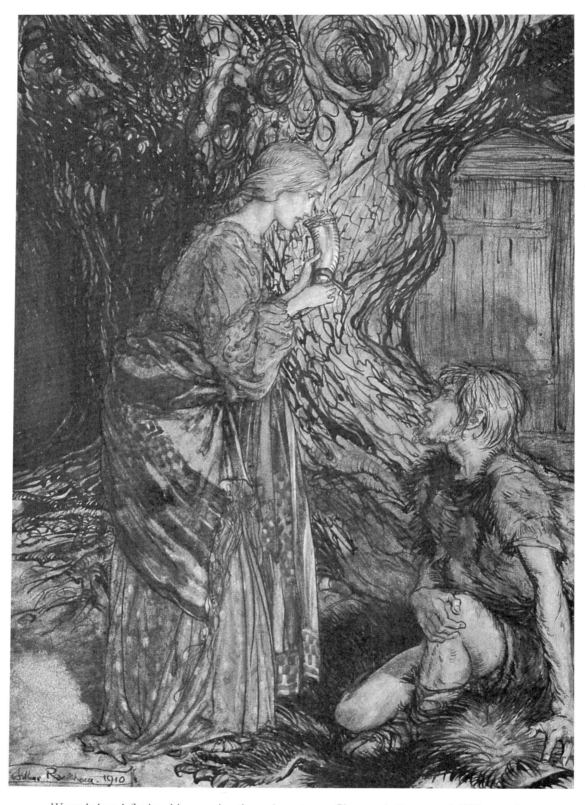

Wounded and fleeing his enemies through a storm, Siegmund, the son of Wälse, seeks refuge in a hut. He is given refreshment by Sieglinde, the wife of cruel Hunding. A tree grows in the hut. In its trunk is a sword that no one has ever been able to remove.

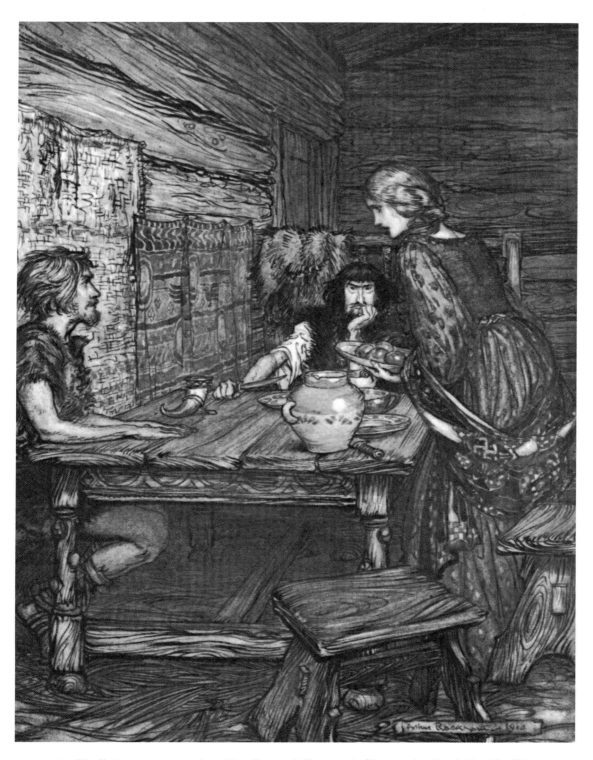

As Sieglinde serves a meal to Hunding and Siegmund, Siegmund tells of his life. His mother had been slain, his sister carried off as a child. His father had later disappeared. Siegmund himself has just been wounded while vainly trying to rescue a girl being wed against her wishes.

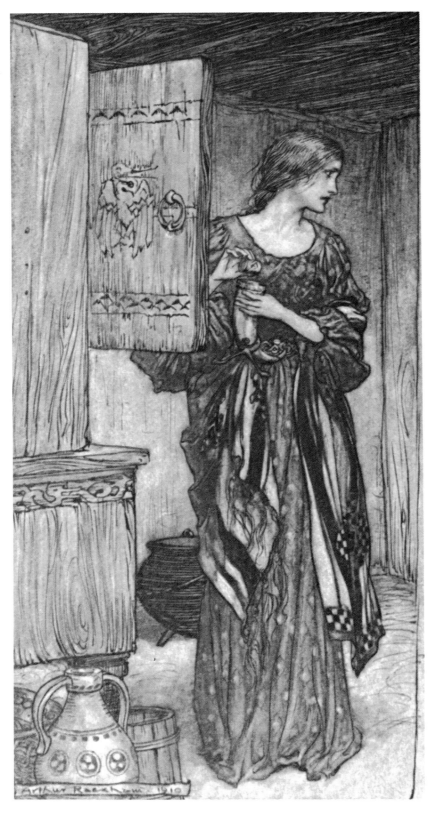

Siegmund's enemies turn out to be Hunding's kinsmen. Hunding, knowing that Siegmund is weaponless, tells him that they will fight in the morning. Sieglinde drugs Hunding's sleeping draft. She and Siegmund fall in love and discover that they are, in fact, brother and sister (and, unknown to both, actually the children of Wotan by a mortal woman).

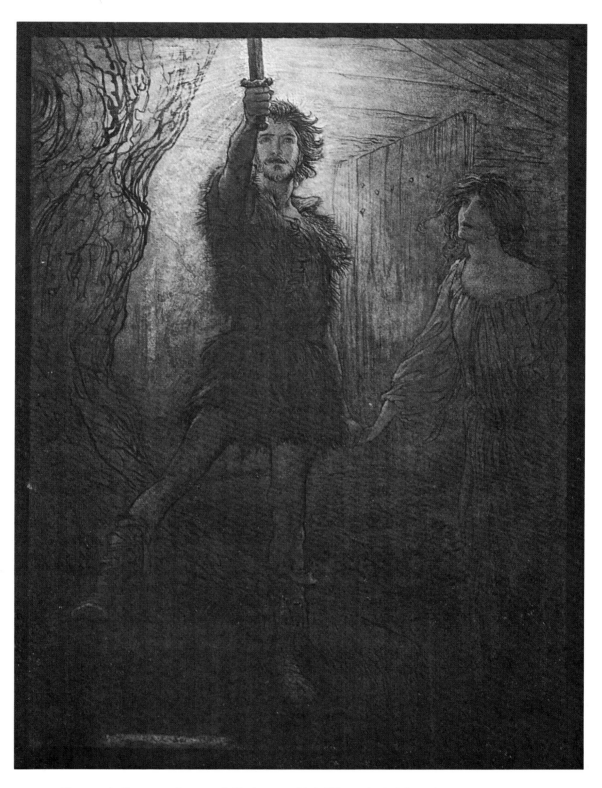

Siegmund discovers the sword Nothung, which Wotan had driven into the tree years before in anticipation of Siegmund's need. He pulls it out and escapes with Sieglinde into the spring night.

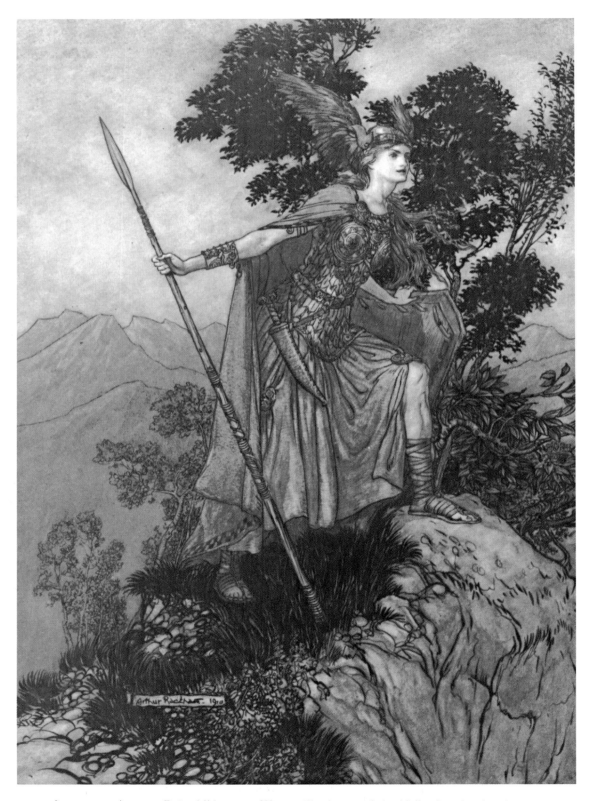

In a mountain pass, Brünnhilde meets Wotan. She is one of the Valkyries, the daughters of Wotan who gather fallen heroes from the field of battle. Wotan orders her to protect Siegmund in the forthcoming fray with Hunding, who is in pursuit.

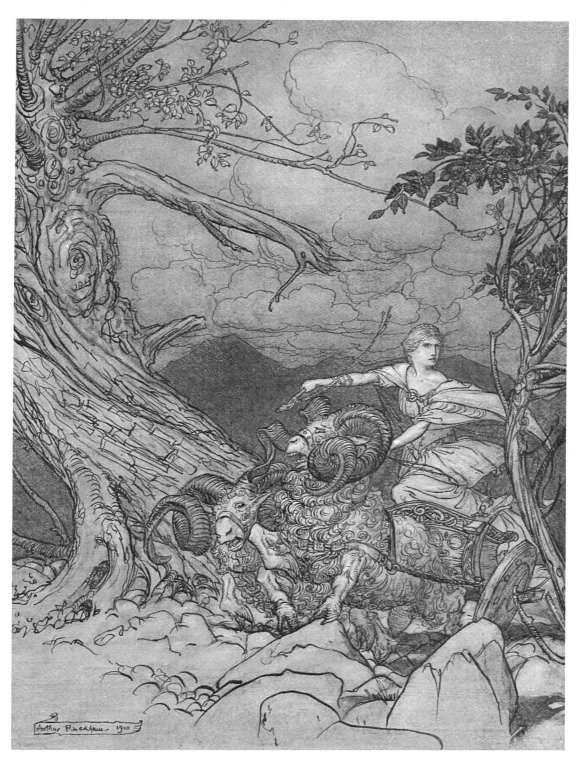

Enraged, Fricka comes to her husband, Wotan. As the goddess of matrimony, the flight and incestuous relationship of Siegmund and Sieglinde are repugnant to her. Using arguments that Wotan cannot resist, she forces him to countermand his orders to Brünnhilde: it is Siegmund who must fall.

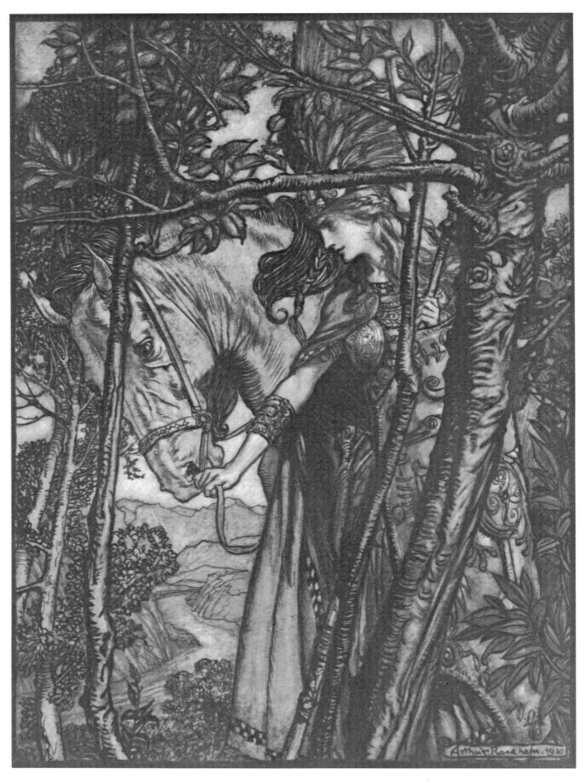

Armed, Brünnhilde returns with her steed Grane. She is shocked to hear Wotan's new commands.

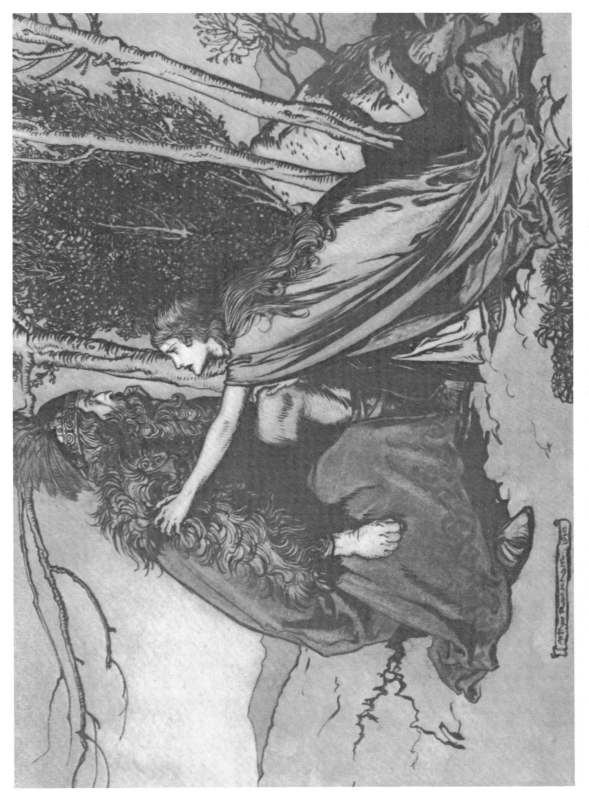

Brünnhilde implores Wotan to reconsider. He is adamant, even though Siegmund's death means the end of all his hopes. He explains how, in an attempt to recover the ring and remove its curse, he had fathered the Wälsungs—Siegmund and Sieglinde. But now Siegmund will not be able to fulfill Wotan's hopes and the gods, tainted by theft and the ring's curse, face the end predicted by Erda.

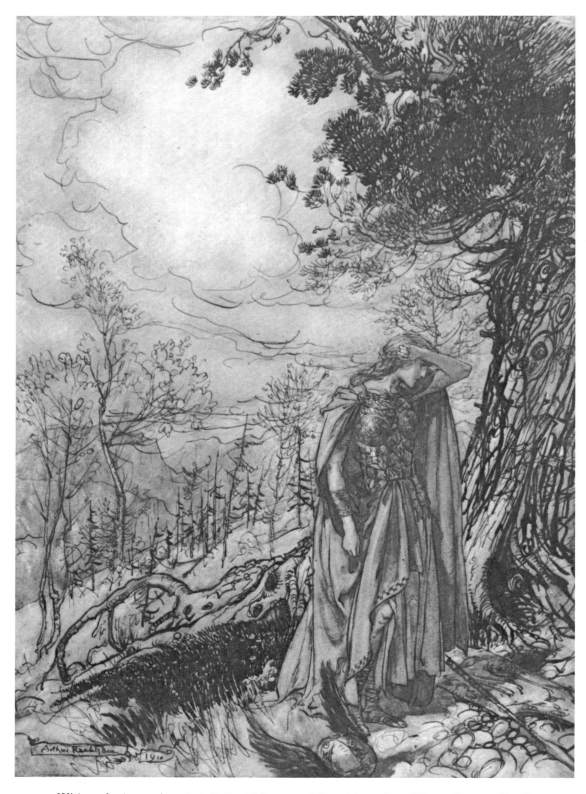

With a final warning that Brünnhilde must follow his orders, Wotan leaves. She is anguished, and slowly prepares for the battle. When she sees Siegmund and Sieglinde approaching, she quickly hides in a nearby cave. The two lovers arrive exhausted.

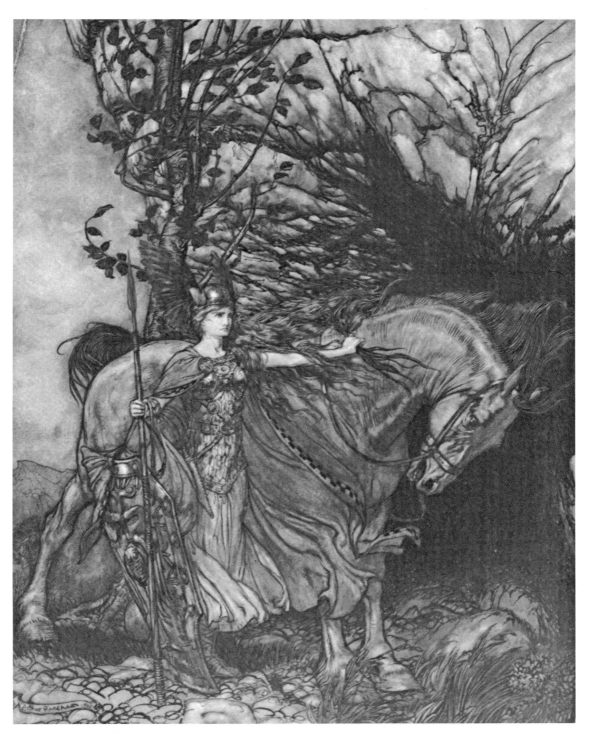

Sieglinde falls into a troubled sleep as Siegmund keeps guard. Majestically, Brünnhilde reveals herself to him and tells him to prepare for death. But his grief and great love for Sieglinde move Brünnhilde to promise that she will defend him against Hunding, in defiance of Wotan. In this she is frustrated, for Wotan appears and Siegmund is killed. Brünnhilde escapes with Sieglinde, followed by the furious Wotan.

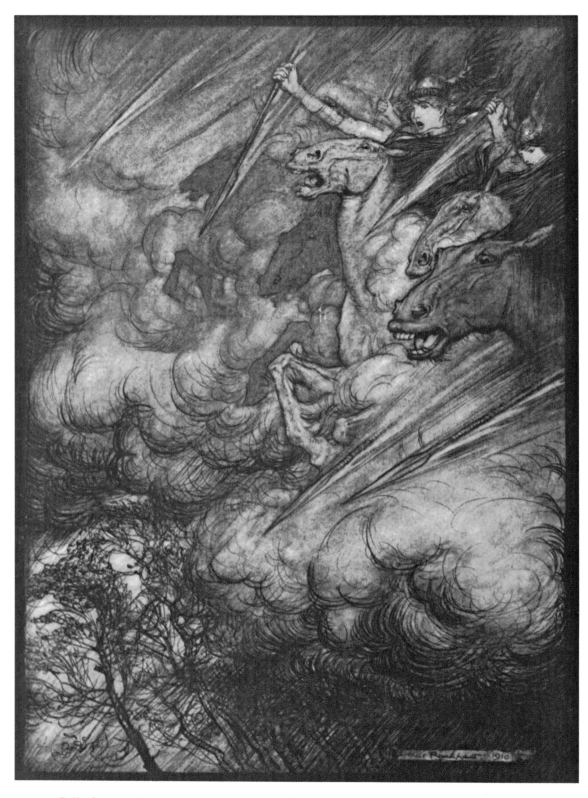

Galloping on their airborne steeds, the Valkyries assemble on a mountaintop. They are about to return to Walhalla with the slain heroes they have gathered from various battlefields. Brünnhilde is late; they look for her anxiously.

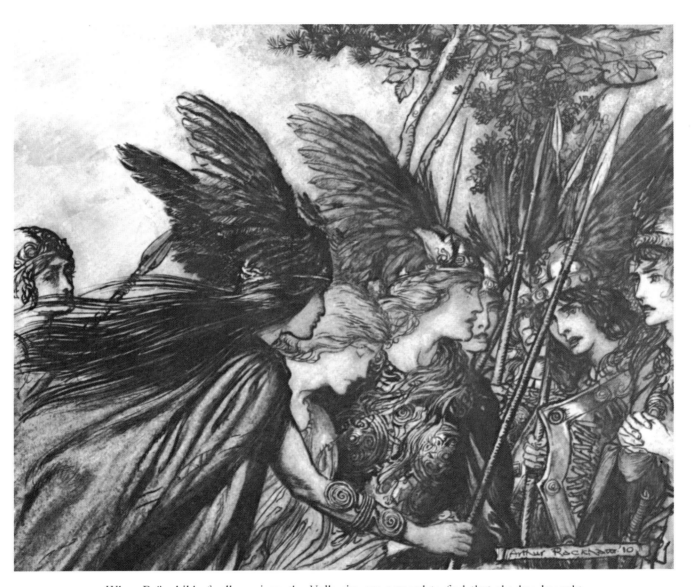

When Brünnhilde finally arrives, the Valkyries are amazed to find that she has brought Sieglinde with her. Brünnhilde quickly explains what has happened and begs their protection.

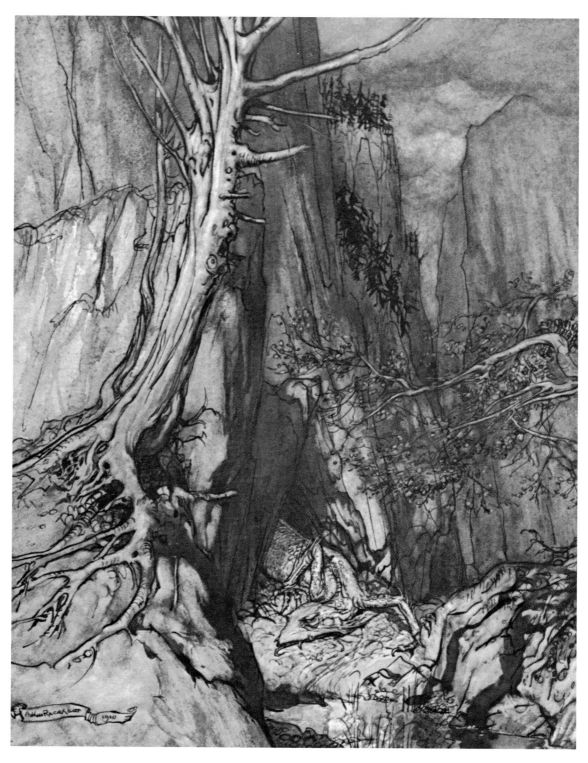

The Valkyries dare not help Brünnhilde, but advise Sieglinde to flee to the forest in the east. Wotan avoids it, for Fafner, having turned himself into a dragon, guards the Nibelung hoard there.

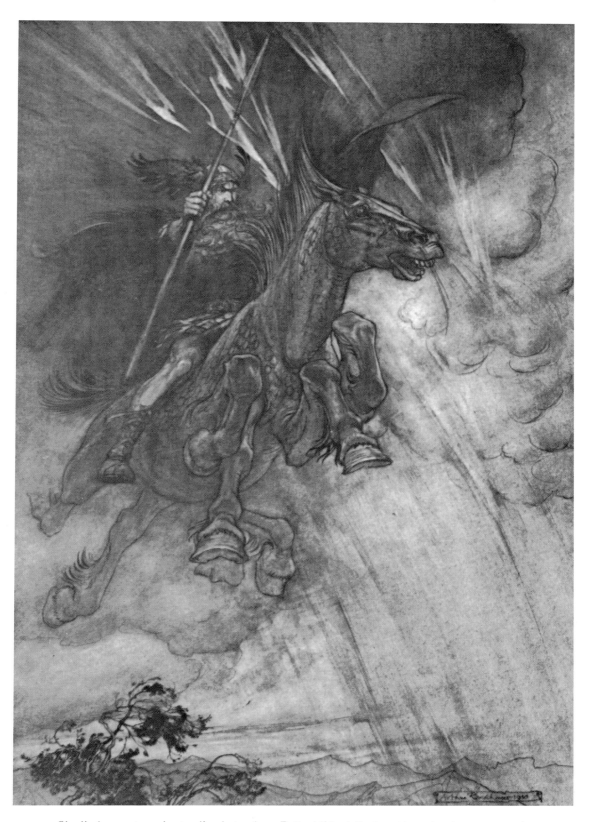

Sieglinde wants only to die, but when Brünnhilde tells her that she is pregnant by Siegmund and will give birth to a great hero—Siegfried—she rushes off to save herself and her unborn child. The storm worsens and Wotan arrives on the rock. He orders the Valkyries away from his renegade daughter.

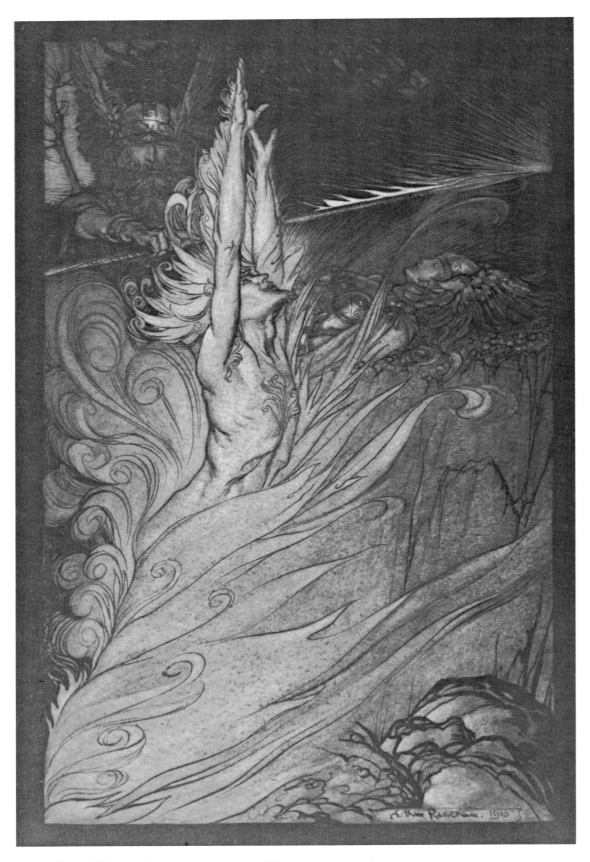

Brünnhilde's punishment is to be terrible: placed in an enchanted sleep on the rock, she will become the mortal wife of the first man who wakes her. Frantically, Brünnhilde pleads that in her sleep she be surrounded by fire so that only a hero will dare wake her. Wotan agrees, places the spell on Brünnhilde and invokes the fire god Loge to surround the mountain with his flames.

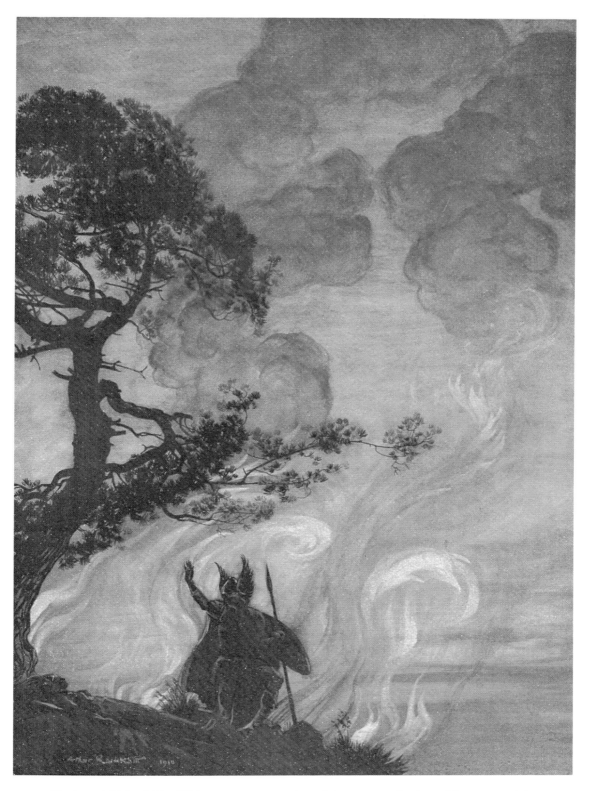

Gazing at Brünnhilde, Wotan pronounces a ban: let no man who fears his spear point cross the fire. After a final lingering glance, the heartbroken god leaves his beloved daughter forever.

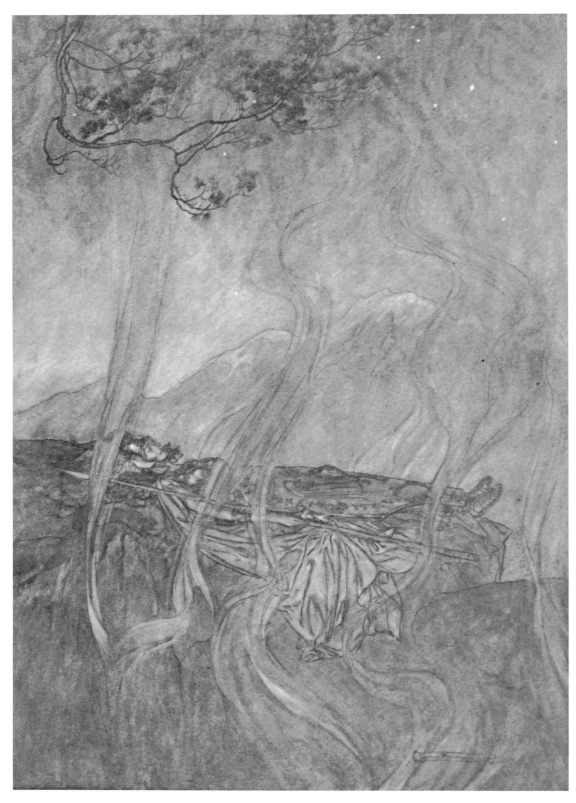

Alone on the mountaintop in the deepening night, the slumbering Brünnhilde awaits
her heroic awakener.

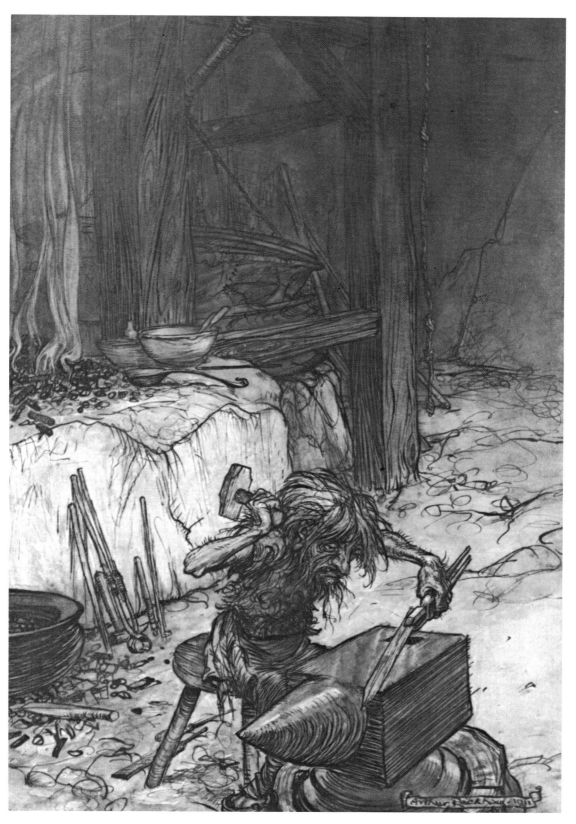

Years later, Mime toils over an anvil in a cavern in a wood. He is making yet another sword for Siegfried, who has grown to young manhood. But labor as he may to make a sturdy weapon, Siegfried always shatters it. Mime wishes he had the skill to reforge Nothung, Siegmund's sword which was shattered in the final battle with Hunding, and whose pieces he has.

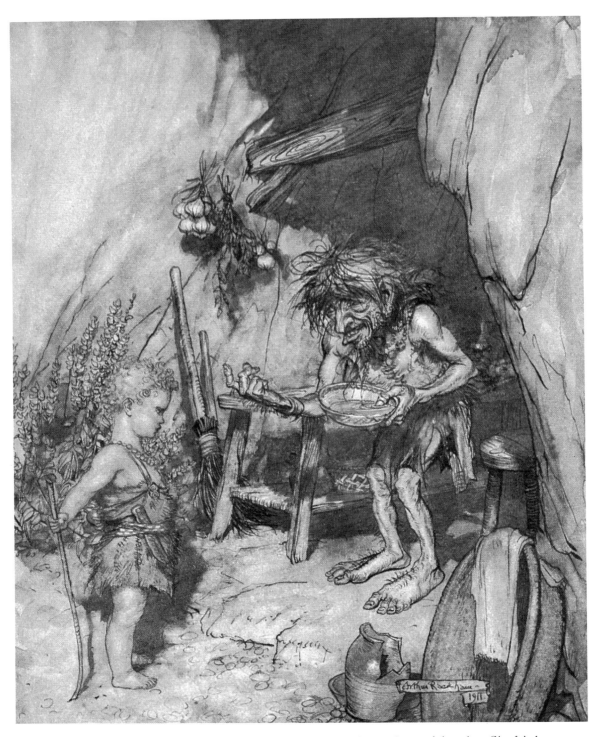

Mime tells Siegfried of the care he took in raising him, and complains that Siegfried
has never returned his love. Siegfried says it was no love at all, and in truth Mime
has raised the boy only so that he will slay Fafner and secure the ring for him.

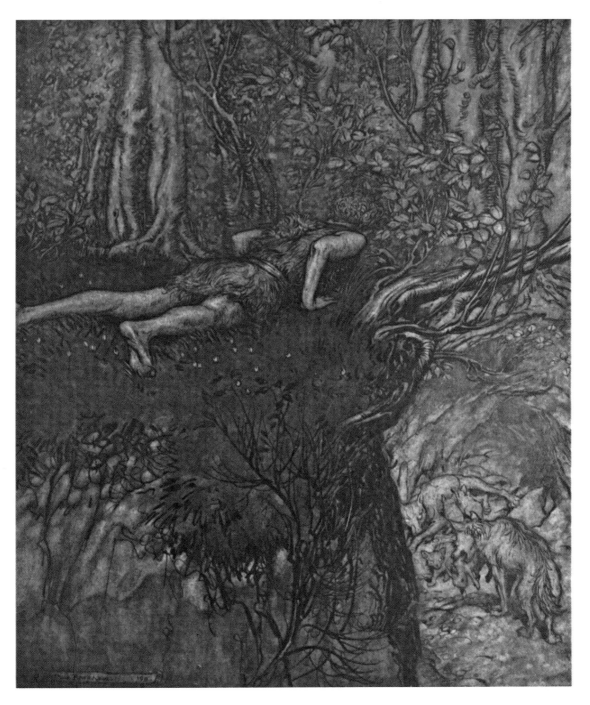

Siegfried says that he has learned of love by watching the way wild animals, such as foxes, tend their young.

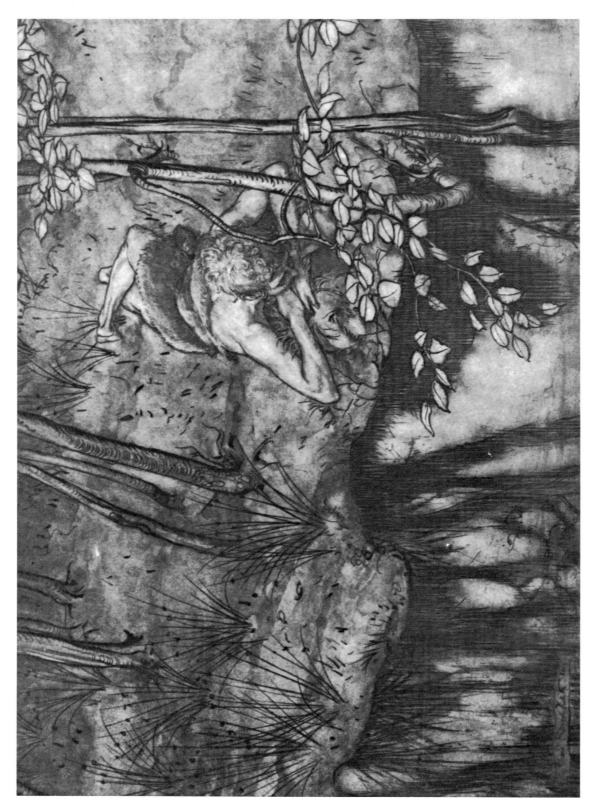

When Mime claims that he is both mother and father to Siegfried, he is met with scorn. Offspring look like their parents, says Siegfried, and once, seeing his reflection in a stream, he had noted that he bore no resemblance to Mime. He demands to know who his parents really were.

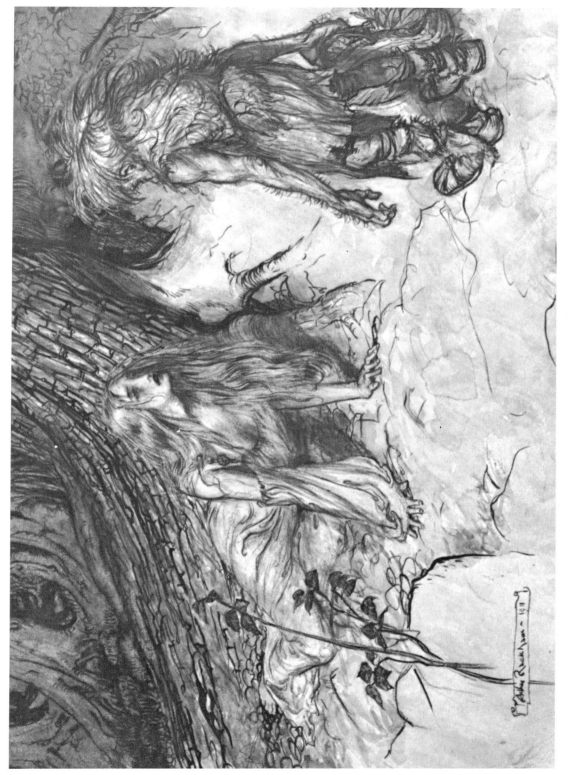

Mime relates how he found Sieglinde in the forest and tended her. She died in bearing Siegfried, but left the fragments of Nothung. Excited by this legacy from his father, Siegfried charges Mime to reforge the sword and goes out into the forest, away from the loathsome dwarf whose very presence he cannot abide.

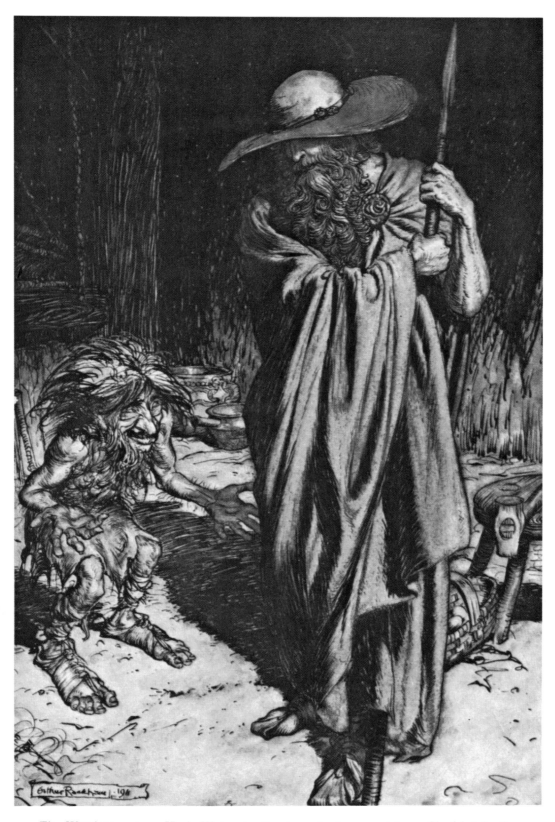

The Wanderer enters. He is Wotan in disguise, who keeps watch on Siegfried in the hope that the boy will be able to carry out the world-redeeming deed he had intended for Siegmund.

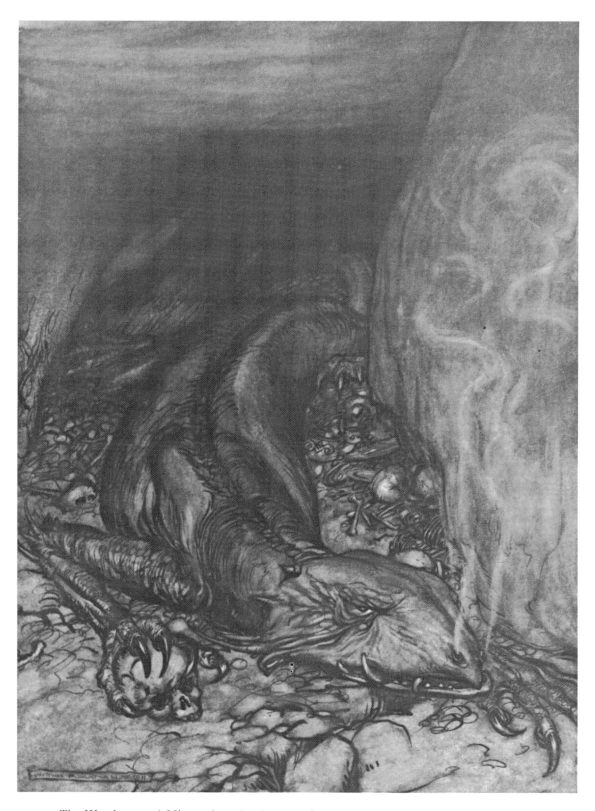

The Wanderer and Mime ask each other questions about the realms of the world. Mime tells of Fafner and the hoard. Warning Mime that the sword Nothung will be reforged only by one who does not know fear and that the same man will cause Mime's death, the Wanderer leaves.

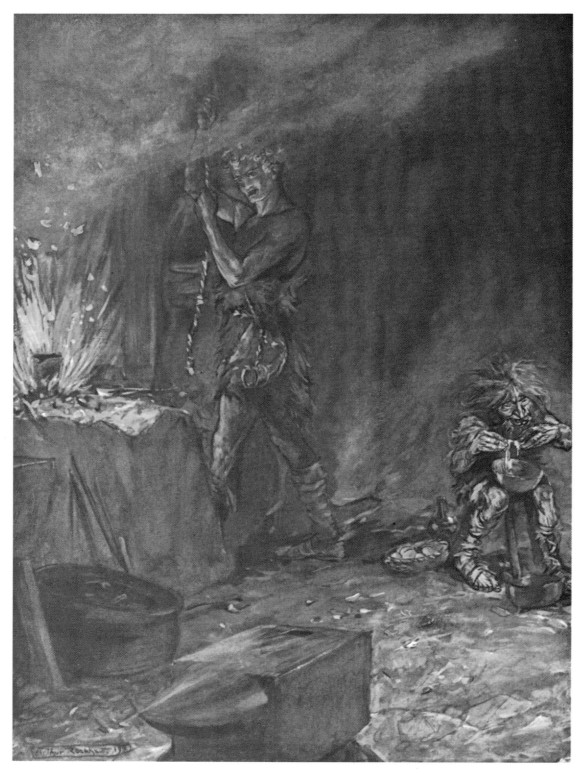

When Siegfried returns he is angered to find Nothung still in pieces. Mime tells him that only someone who does not know fear can reforge it. Siegfried says that person is he and sets about work. Mime promises to teach him fear at Fafner's lair, and prepares a deadly potion he intends to give the hero after he has slain the dragon. Siegfried files down the sword, melts it and casts it anew.

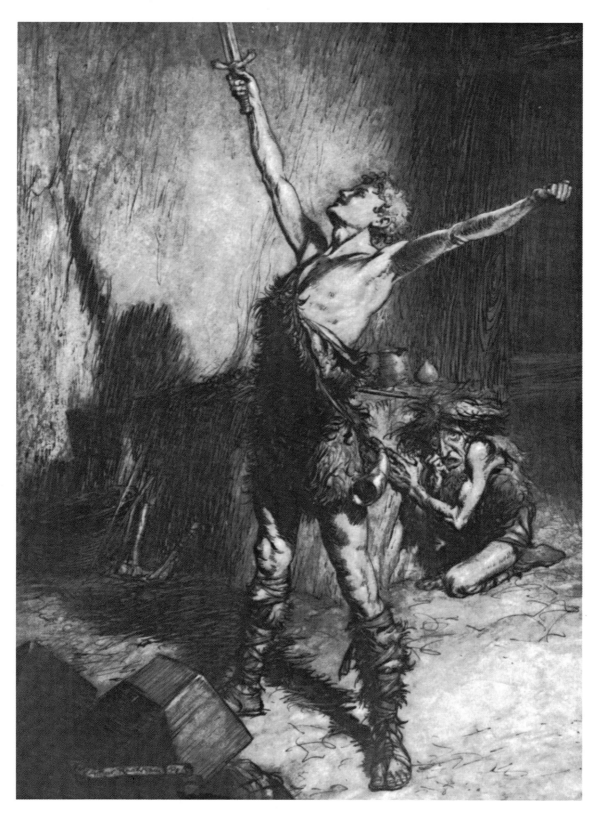

Having remade his father's sword, Siegfried tests Nothung on the anvil, which is split in two with a single stroke. Mime cowers in fear, remembering the Wanderer's prophecy.

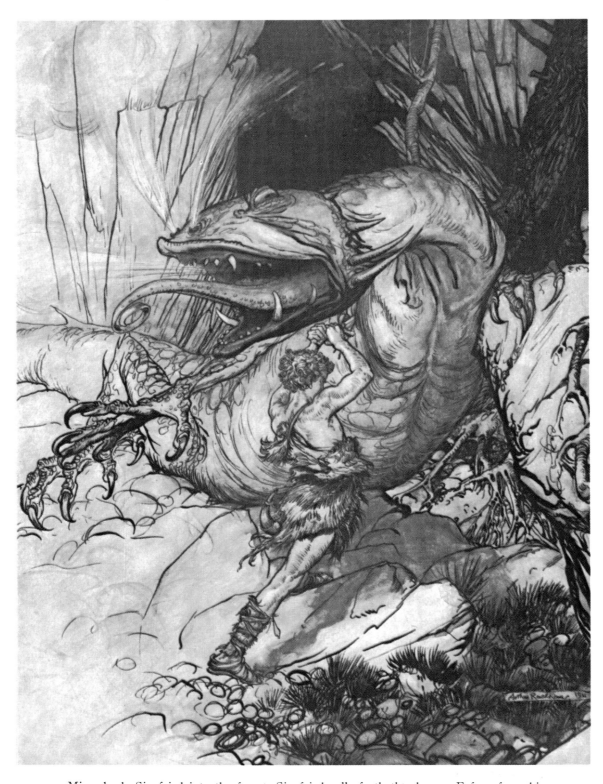

Mime leads Siegfried into the forest. Siegfried calls forth the dragon Fafner from his lair and slays him.

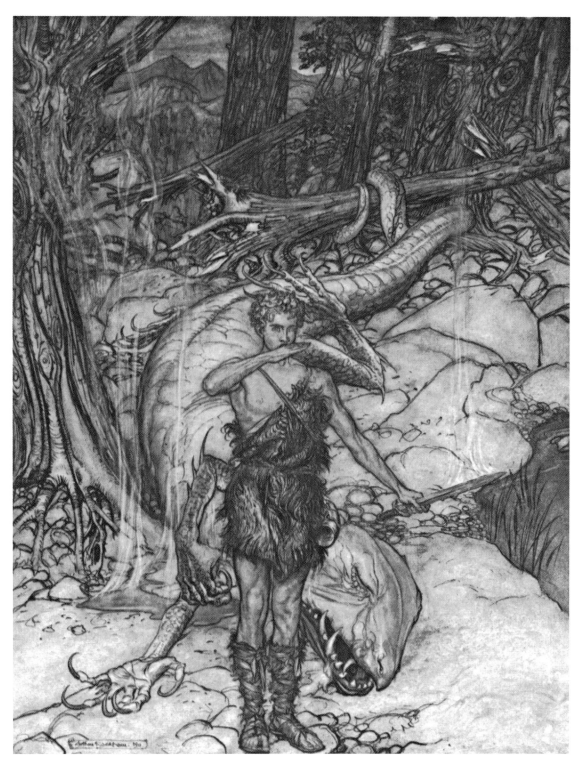

Fafner's blood trickles onto Siegfried's hand, burning it. Siegfried puts it to his mouth to soothe it and discovers that the blood has given him the power to understand the speech of birds. A forest bird tells Siegfried of the treasure hidden in the cave.

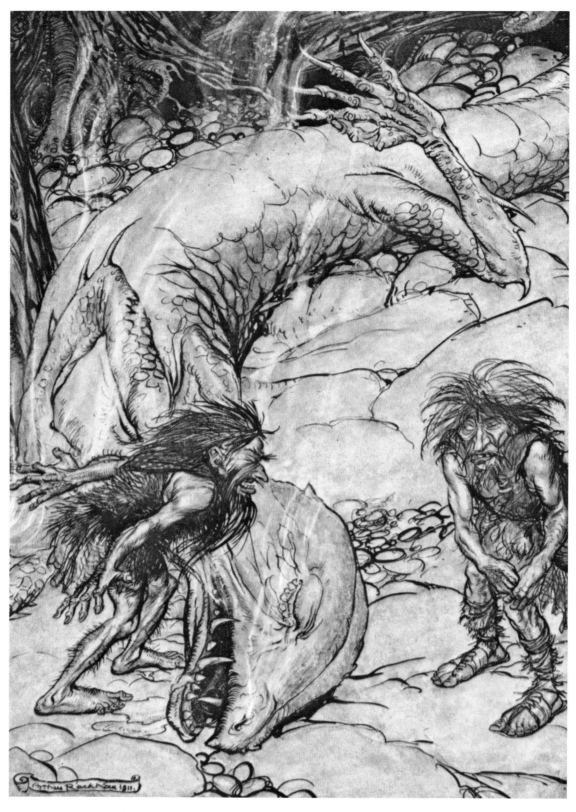

As soon as Siegfried enters the cave, Alberich appears and quarrels with Mime over possession of the hoard. Alberich slinks off. When Siegfried emerges he wears the ring and has the Tarnhelm. He is able to read Mime's thoughts about killing him with the potion and so slays the dwarf. The bird tells him that a wife awaits him atop a mountain surrounded by fire, and leads him to her.

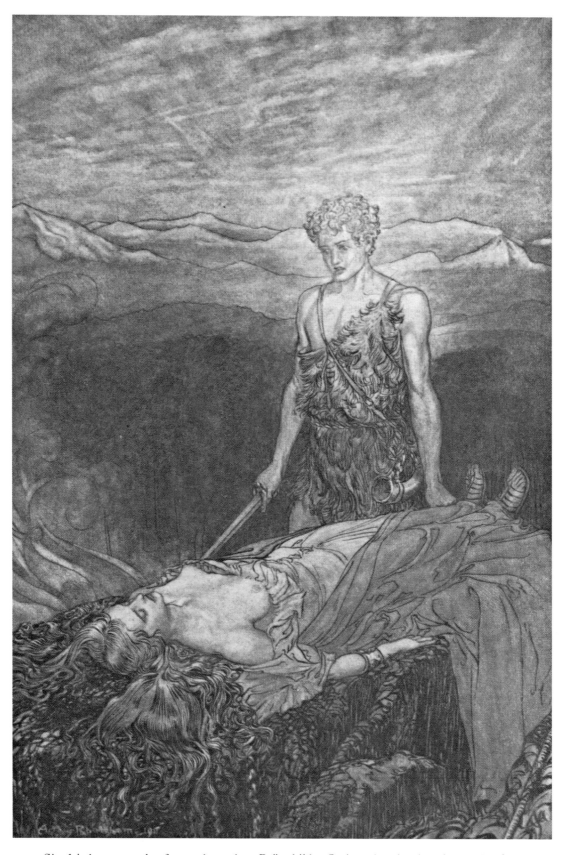

Siegfried crosses the fire and reaches Brünnhilde. Seeing the sleeping form, the first woman he has ever known, he is filled with fear. He sinks upon Brünnhilde and kisses her.

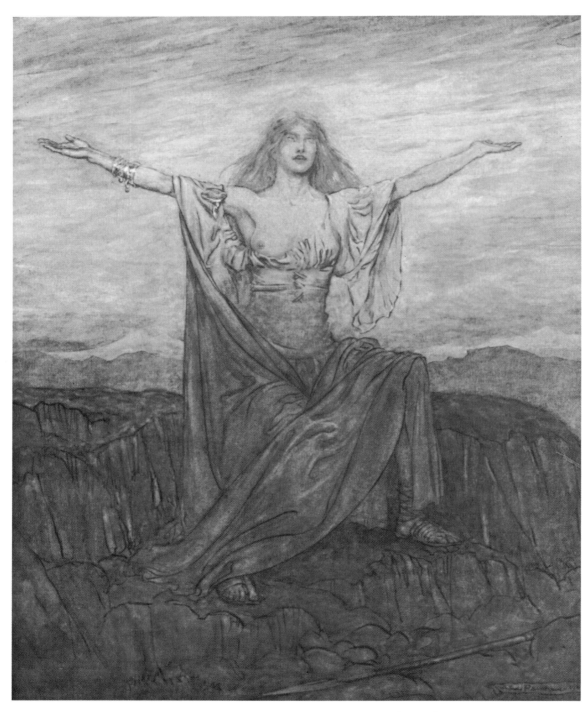

Brünnhilde is finally awakened. Joyously, she salutes the sun.

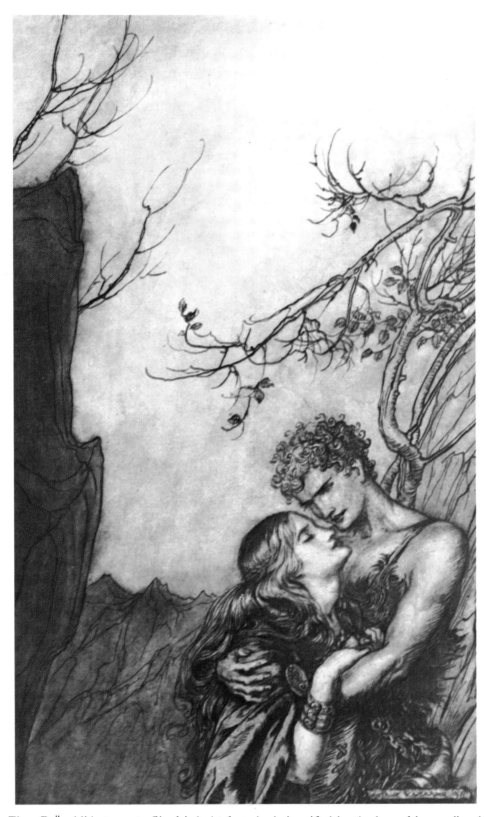

Then Brünnhilde turns to Siegfried. At first she is horrified by the loss of her godhood. Soon, however, she responds as the mortal woman she has become and, bidding a final farewell to the splendor of Walhalla, offers Siegfried her love.

It is night. On Brünnhilde's rock the three Norns—the Fates—pass a golden rope back and forth, reflecting on the past and looking to the future, which bodes ill.

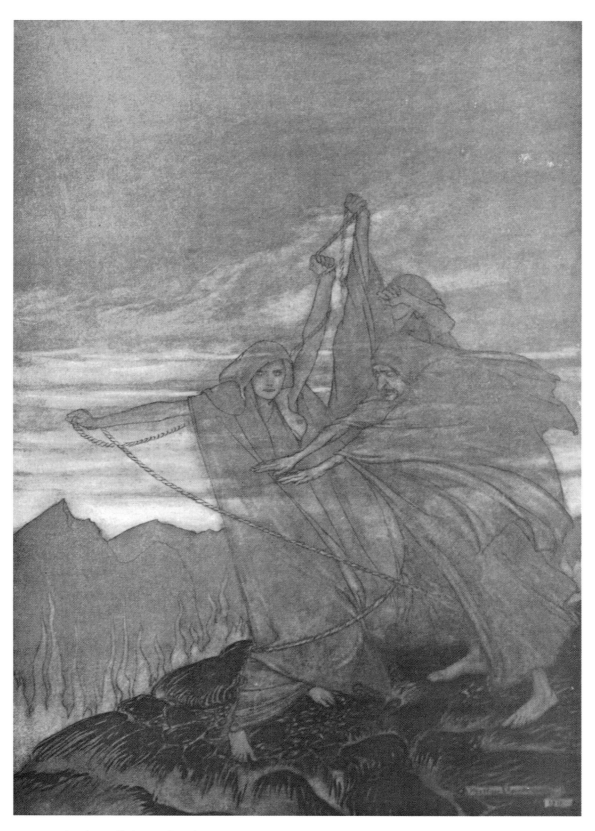

As dawn lightens the sky, the rope suddenly breaks. The days of the old order are numbered; the Norns sink into the earth, their wisdom ended.

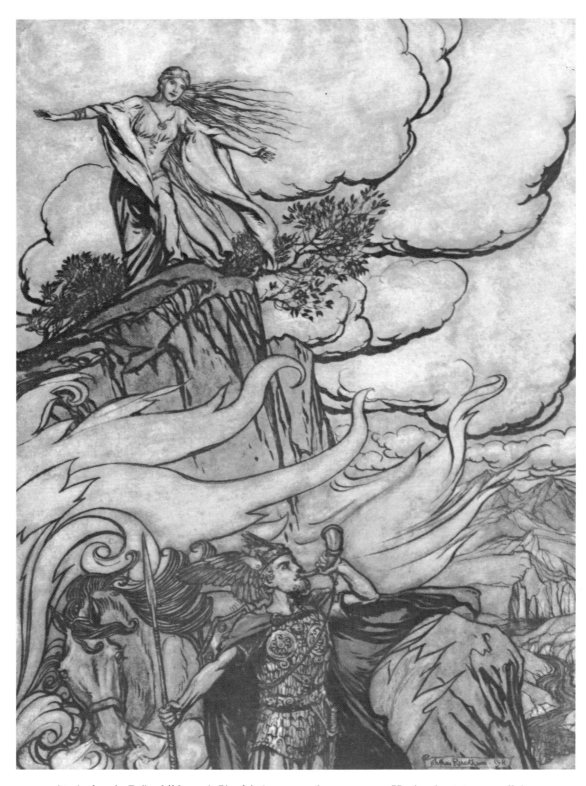

At daybreak Brünnhilde and Siegfried emerge from a cave. He is about to go off in search of adventure. To plight their troth, they exchange presents. Brünnhilde gives Siegfried her horse Grane; Siegfried gives her the fatal ring.

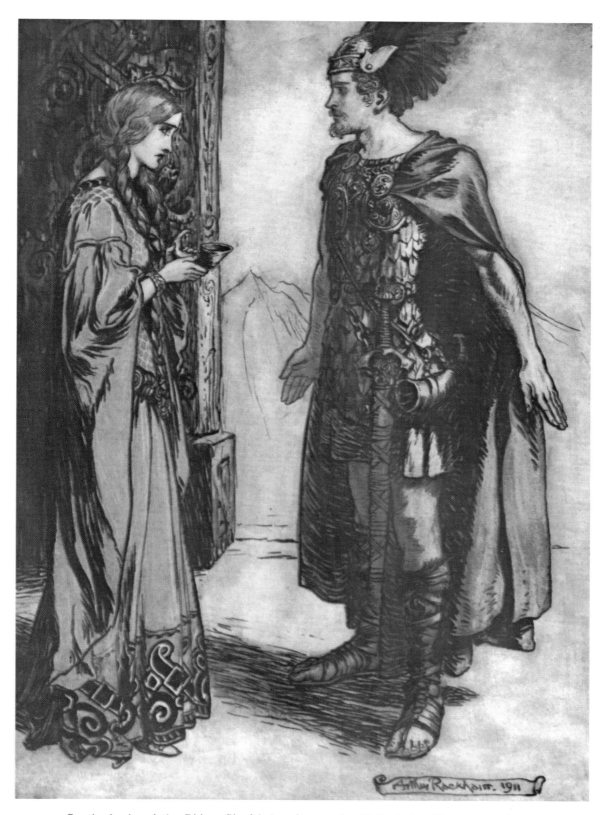

On the banks of the Rhine, Siegfried arrives at the Hall of the Gibichungs, who are ruled by the weak-willed Gunther, his sister Gutrune and their half-brother Hagen. To make Siegfried Gutrune's husband and so gain a prestigious kinsman, they give him a potion that causes him to forget Brünnhilde. Then, to secure a worthy wife for Gunther, Hagen suggests that Siegfried conquer the fabled Valkyrie for his new brother-in-law. Oblivious of his past relationship, the hero agrees.

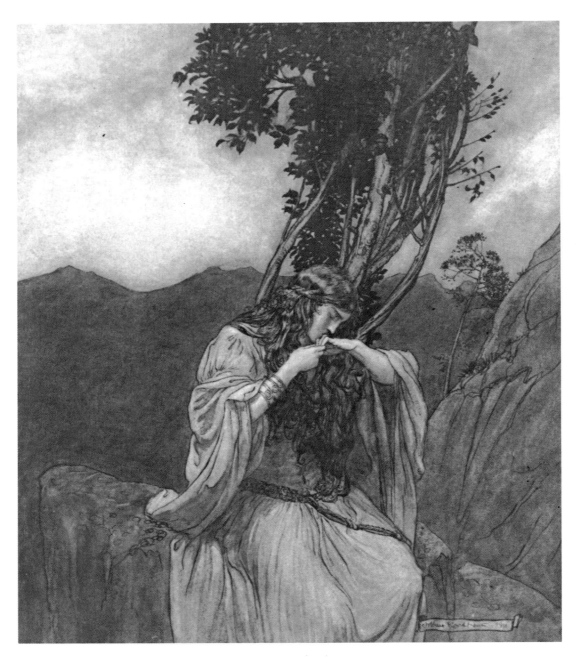

On the mountaintop, Brünnhilde kisses the ring. Suddenly she hears thunder and, looking up, sees her Valkyrie sister Waltraute riding toward her, even though Wotan had forbidden the Valkyries ever to see Brünnhilde again.

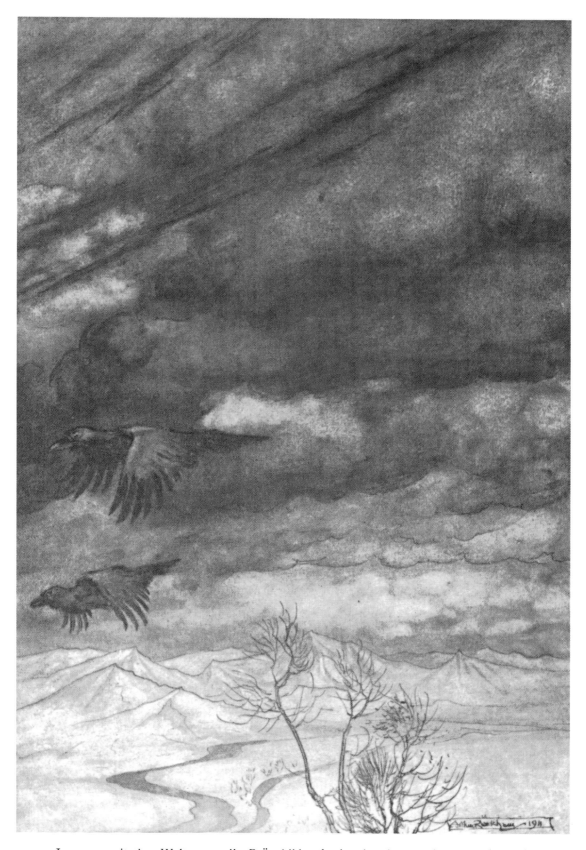

In great agitation Waltraute tells Brünnhilde of what has happened among the gods since she was cast from them. No longer does Wotan go forth into the world. Instead he sits in Walhalla surrounded by the heroes; logs are heaped high around the castle. The god only hears of the world from his two ravens.

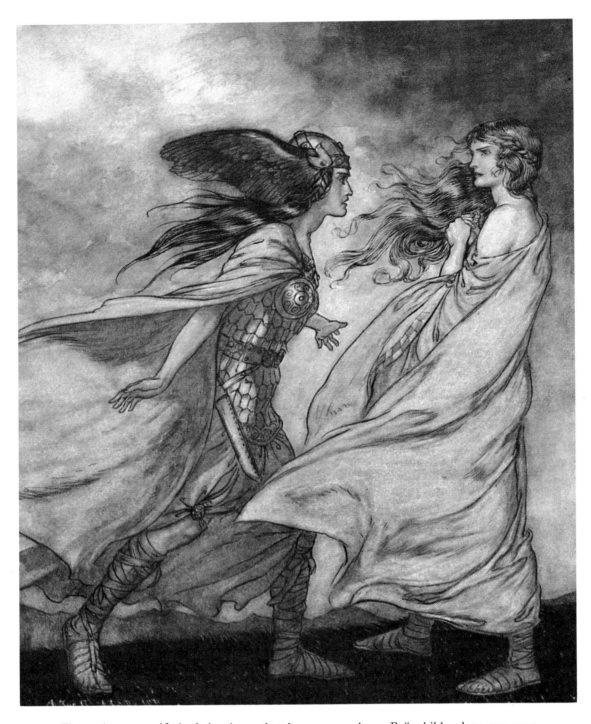

The gods are terrified of the doom that hangs over them. Brünnhilde alone can save them by returning the ring to the Rhinemaidens, cleansing it of its curse. But Brünnhilde refuses, valuing the token of Siegfried's love more than the pomp of Walhalla. Waltraute dashes off in despair. At night the protective fire encircles the rock. The false Gunther (actually Siegfried wearing the Tarnhelm) breaks through and captures the humiliated Brünnhilde. Seizing the ring, he puts it on his finger.

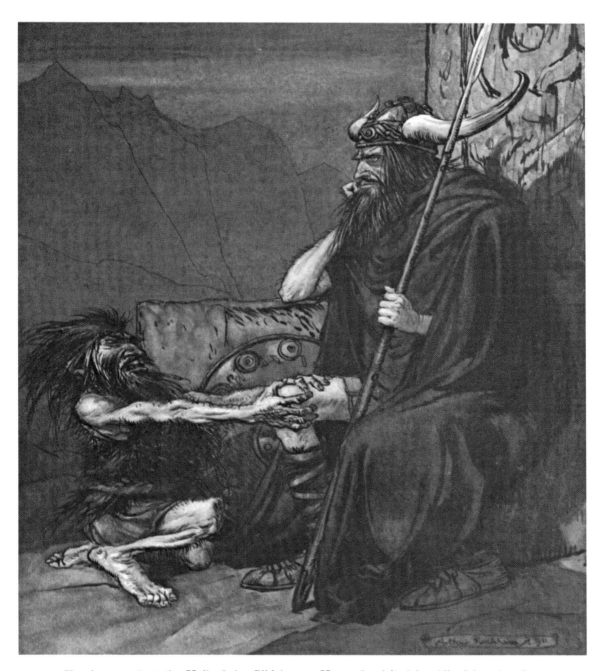

Keeping watch at the Hall of the Gibichungs, Hagen is visited by Alberich, who plots
with him to recover the ring.

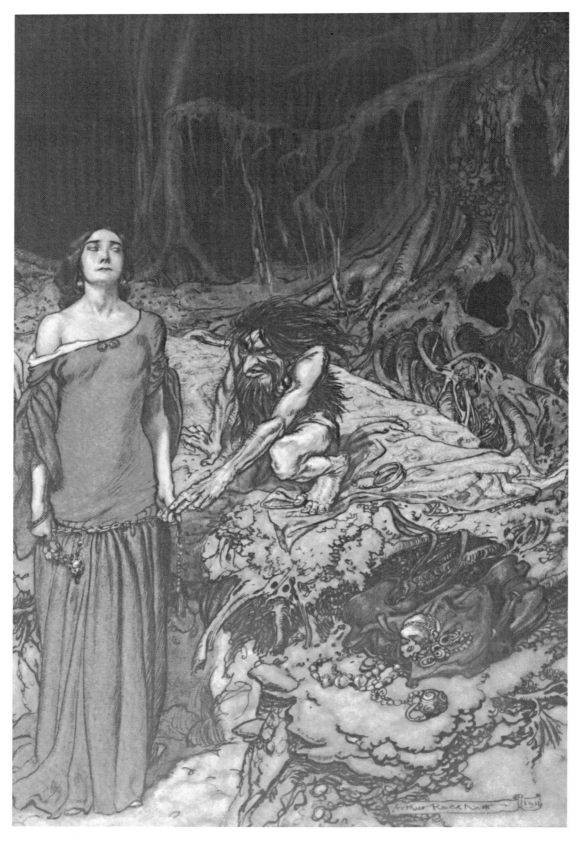

For Hagen is the son of Alberich. The evil Nibelung had gained the favors of Grim-
hilde, mother of Gunther and Gutrune. Thus the battle for the ring has been passed to
a new generation. The gods are represented by the unwitting Siegfried, the Nibelungs
by the ruthless Hagen.

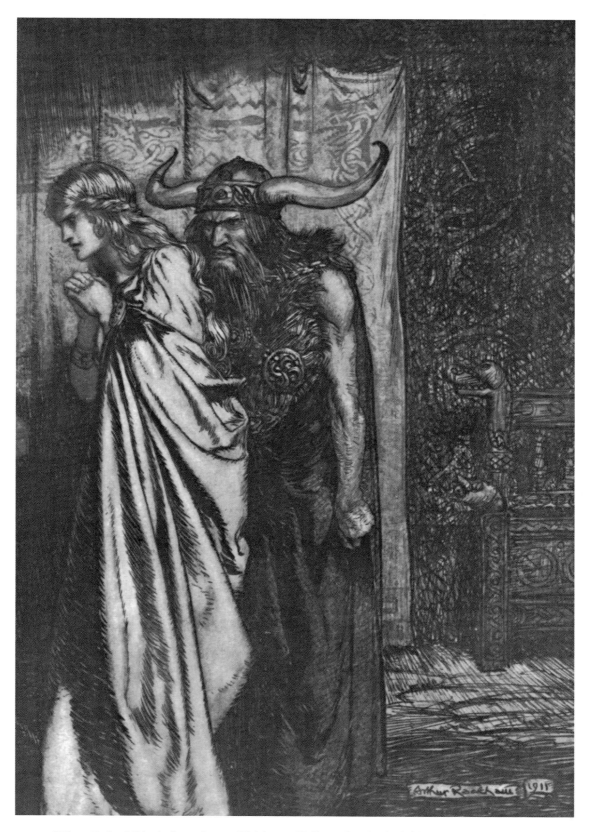

When Brünnhilde is brought to Gibichung Hall as Gunther's bride, she sees the ring on the finger of Siegfried, who has returned to his normal form. Realizing that she has been deceived, she reveals Gunther's cowardice to all, and with Hagen and Gunther plots her revenge. The next morning a hunting party will set out with Siegfried. Hagen will murder him during the hunt.

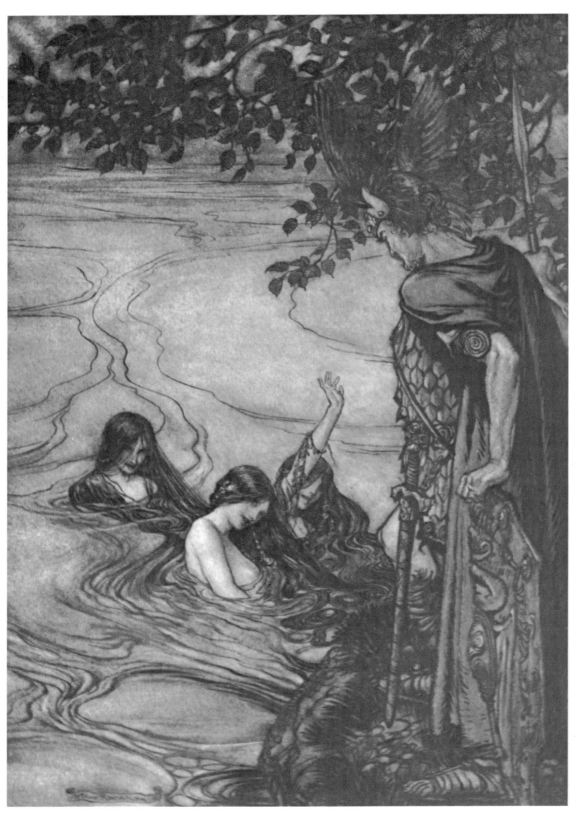

During the hunt Siegfried strays by the Rhine to look for his catch, which an elf has stolen from him. He meets the Rhinemaidens, who tease him and ask for the ring in exchange for his booty, which they have taken and hidden. He agrees after some hesitation.

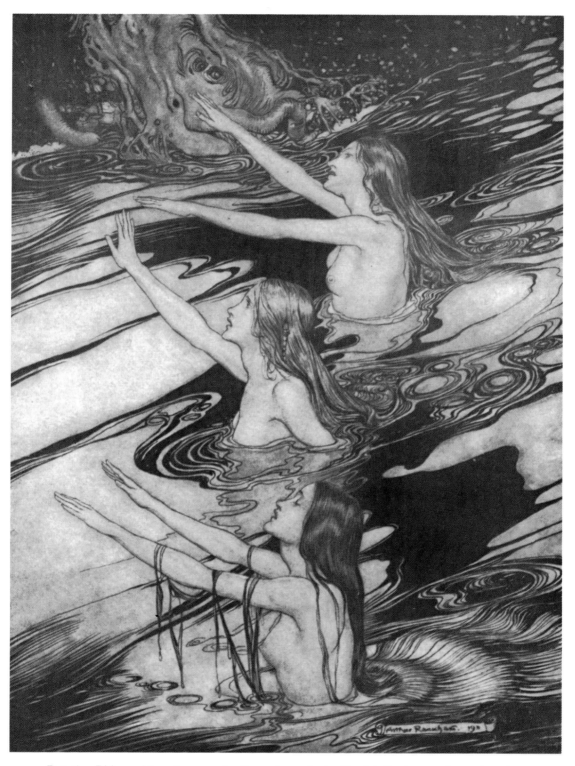

But the Rhinemaidens become deadly serious. It is Siegfried's fate to keep the ring and fall victim to its curse. They bid the hero farewell and swim off to see Brünnhilde, to whom they will explain everything. By the end of the day she will have inherited the ring.

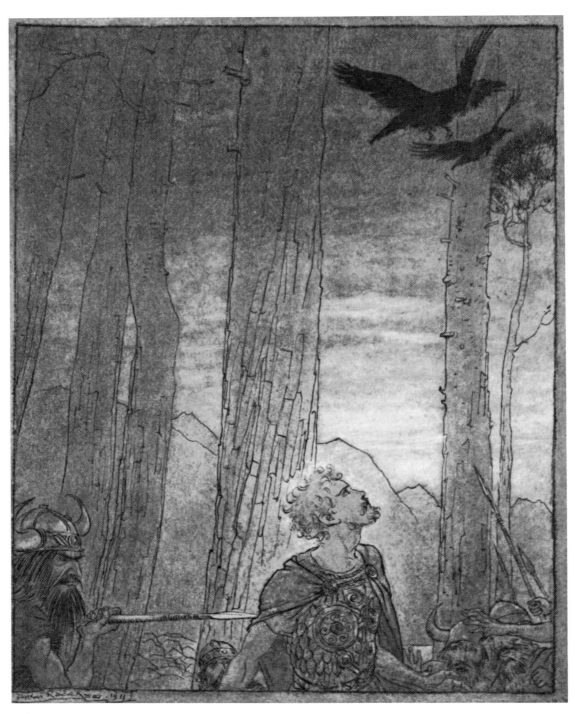

Siegfried rejoins the hunting party and is speared in the back by Hagen. His body is borne back to the Gibichung Hall.

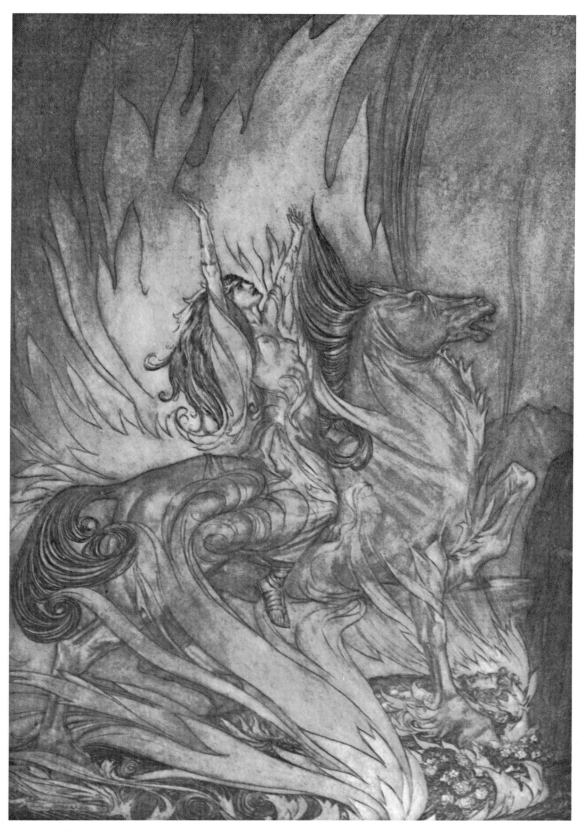

Brünnhilde now realizes that the world must be purged of the terrible curse, that the bloody chain of events going back to the theft of the Rhinegold must be broken by her sacrifice. Bidding Wotan eternal rest, she puts the ring on her finger, mounts Grane and rides onto Siegfried's funeral pyre. The fire spreads and consumes the entire hall.

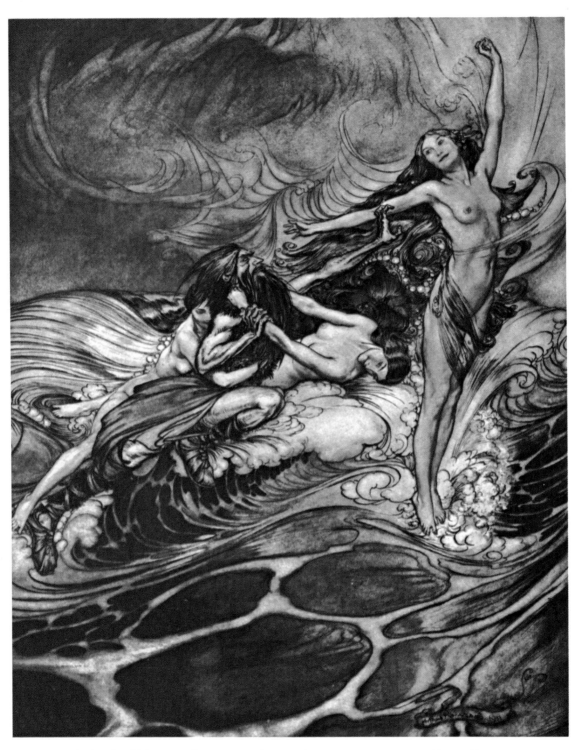

Suddenly the Rhine overflows its banks, bearing on its crest the Rhinemaidens, who recover the ring from the ashes. Like a madman, Hagen plunges into the flood after the coveted prize, only to be dragged under to his death by Woglinde and Wellgunde. As the Rhinemaidens rejoice in their recovered gold, a ruddy glow illuminates the horizon. Walhalla is aflame and the order of the gods has come to an end. In the new age the world will be ruled by love alone.